WITHDRAWN
Drawing
Workshop II

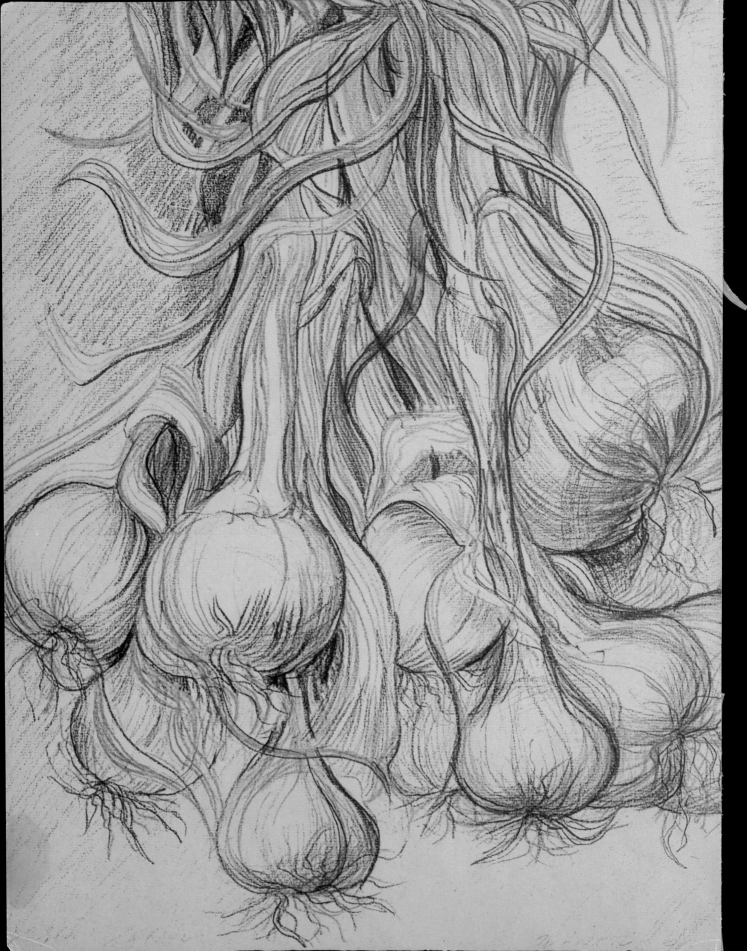

Drawing
Workshop II

Marie-Claire Isaaman

DK

LONDON, NEW YORK, MELBOURNE,
MUNICH, DELHI

Project Editor Kathryn Wilkinson
Project Art Editor Anna Plucinska
Production Editor Sharon McGoldrick
Managing Editor Julie Oughton
Managing Art Editor Christine Keilty
Production Controller Linda Dare
US Editor Meg Leder
Photography Andy Crawford

Produced for Dorling Kindersley by
cobaltid
Art Editors Rebecca Johns, Paul Reid
Project Editor Marek Walisiewicz

First American Edition, 2007

Published in the United States by
DK Publishing
375 Hudson Street
New York, New York 10014

07 08 09 10 11 10 9 8 7 6 5 4 3 2 1

PD188–May 2007

Published in Great Britain by Dorling Kindersley Limited.

A catalog record for this book
is available from the Library of Congress.

ISBN: 978-0-7566-2846-8

DK books are available at special discounts when
purchased in bulk for sales promotions, premiums,
fund-raising, or educational use. For details, contact:
DK Publishing Special Markets, 375 Hudson Street,
New York, New York 10014 or SpecialSales@dk.com.

Color reproduction by Wyndeham Prepress, London
Printed and bound in China by
Hung Hing Offset Printing Company Ltd
Discover more at
www.dk.com

Contents

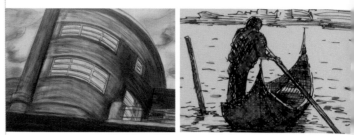

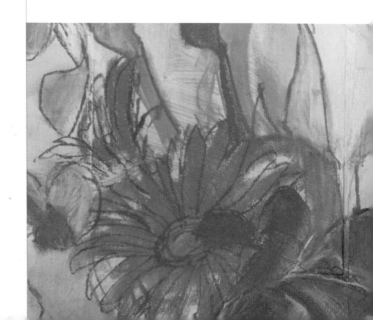

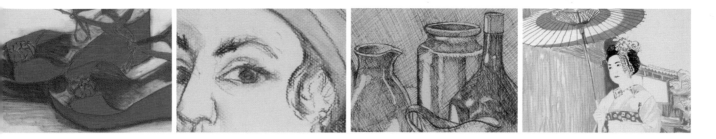

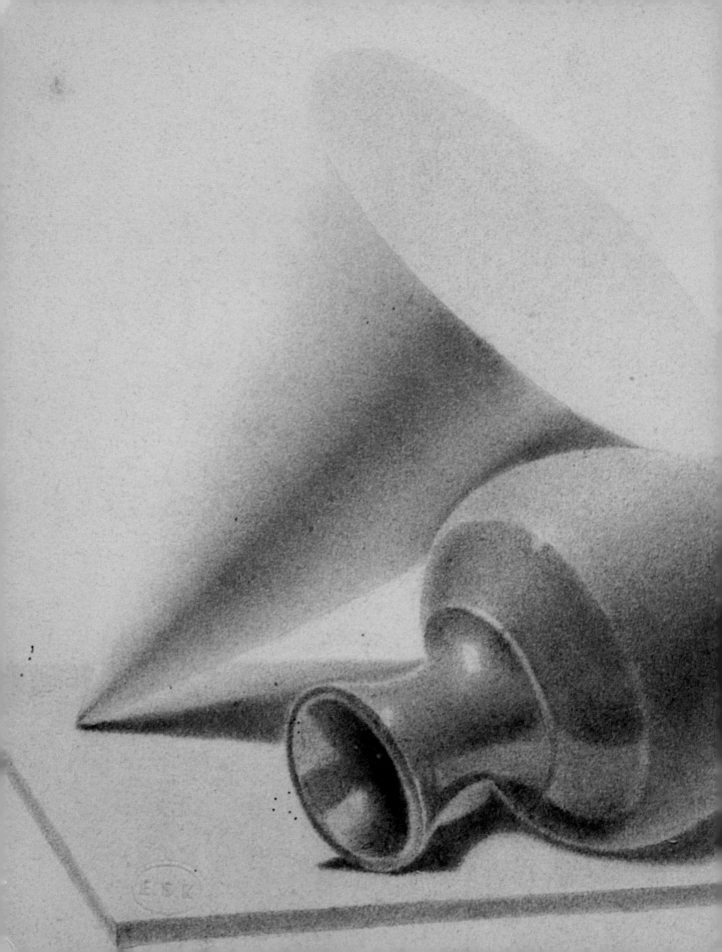

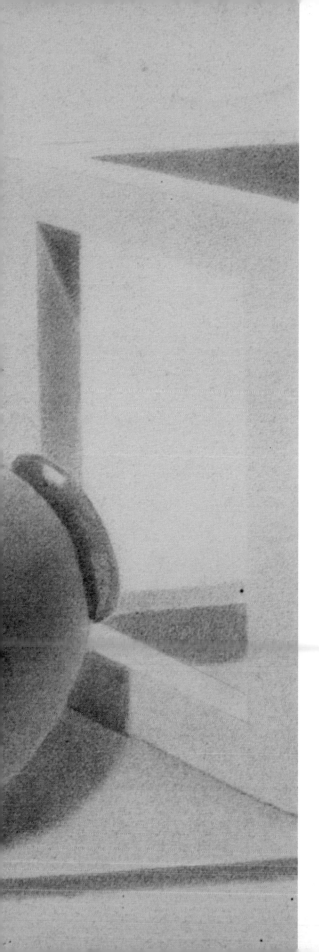

Introduction

What is drawing? Traditionally, it has been regarded as a secondary art – a preparatory stage for painting or sculpture, or a purely technical skill. These notions, however, ignore the vast creative potential of drawing as a means of exploring content, process, and analytical skills. Happily, this potential is now being realized, and drawing is experiencing a massive resurgence in contemporary art and design practice. There are two main reasons for its renewed popularity. First is accessibility. You don't need expensive equipment or materials to make a drawing, and your work can be quick to execute and easy to review and revise. Often, it is the capacity for spontaneous expression – ideas distilled to their very essence – that makes drawing so compelling, but it is

also – conversely – a medium capable of being detailed, elaborate, and expansive. Second is diversity. Drawing practice takes in everything from classical still life drawing and landscape to advanced digital manipulation and abstract expression; it encompasses analytical pencil drawing, gestural charcoal portraiture, as well as exuberant oil pastels that have many of the qualities of oil painting. Indeed, it could be argued that no other form of graphic expression is so versatile. Understanding the wide range of ideas and processes in drawing will help you advance your drawing practice beyond basic ideas and traditional conventions. You will be able to make drawings that are not just competent, but truly interesting.

A question of intent

To make interesting drawings, you must first identify your intentions. What is your subject? How will you draw it? And, perhaps most importantly, why will you draw it? Reflection and research – scouring the world around you for visual inspiration, recording and developing ideas in a sketchbook – are the cornerstones of all revealing work. Once you have decided on your subject and your purpose, you need

to match it with a suitable process. Consider the properties of your subject that you wish to reveal; for example, a simple bunch of flowers has many descriptors, such as natural, colorful, textured, fresh, and ephemeral. Choosing which to explore, and in which media, will give your activity a clear purpose. Try new processes; at first, some will not work, but they will still flex the self-critical part of your brain and help you develop an analytical framework – essential if you are to progress to an advanced level.

The final chapter of this book looks at contemporary devices that allow you to explore content and process in progressive ways – precisely the ways that are expanding the territory of drawing in today's society. What sets these contemporary practices apart from the historic roots of drawing is that there now exists a whole generation of artists for whom drawing is the primary activity. They have revitalized this ancient art, and recaptured the magic of pure, direct imagery in an era when images are ubiquitous and often superfluous.

The aim of this book is to inspire your practice, and give you the means to contribute to the new wave of drawing, but above all to help you enjoy the simple act of making marks on paper.

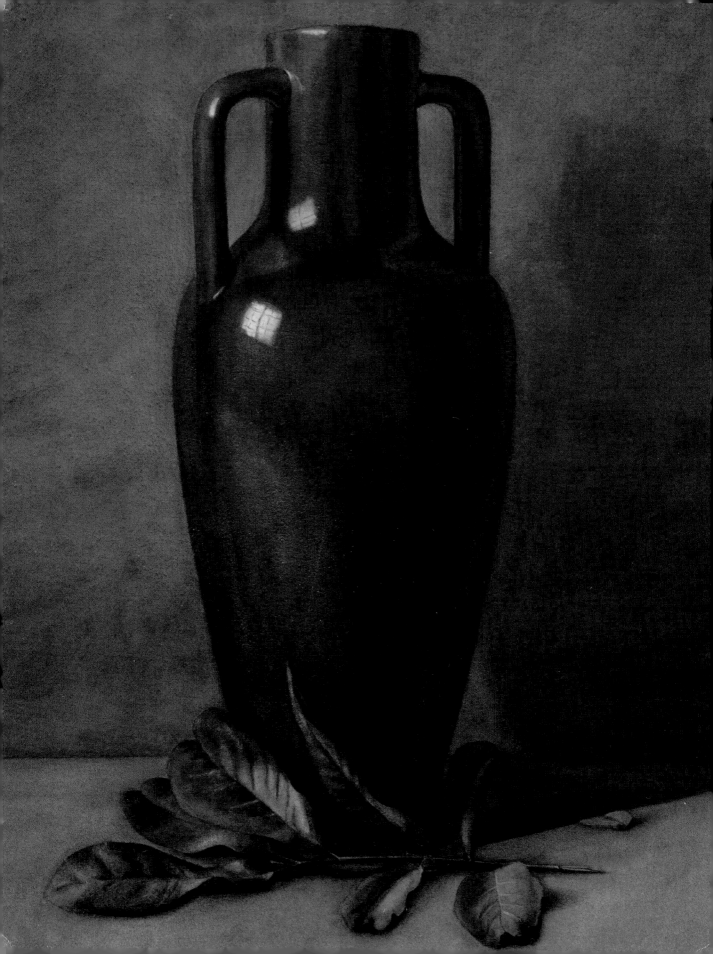

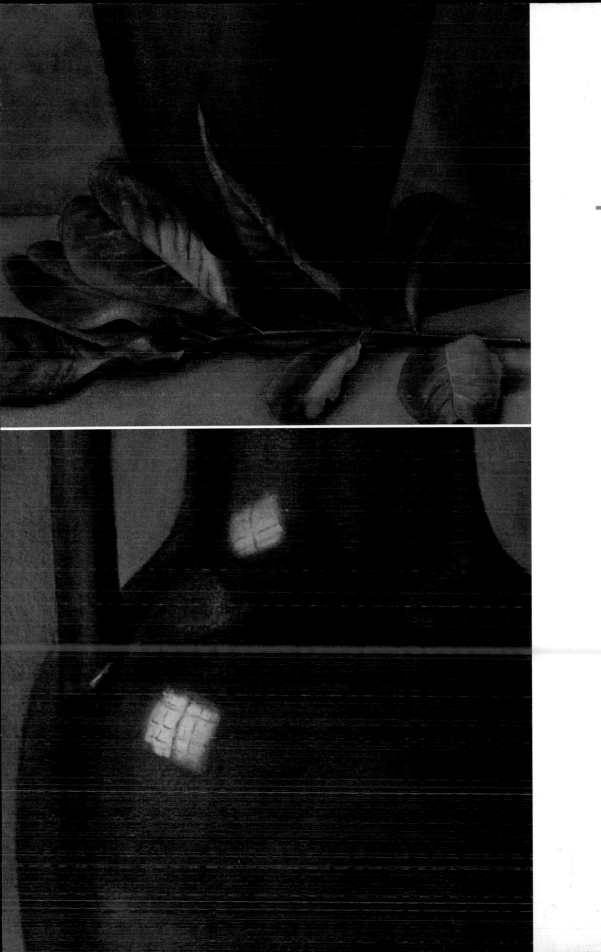

Preparation

Pencils, pens, and brushes

Drawing is rightly associated with freedom of self-expression, but even so, you cannot draw without some kind of tool to extend the eye and hand. The fundamental tools of drawing are the simplest and most portable – pencils, pens, and brushes – and it is worth spending the time to find which are suited to your interests and temperament. This will help you define and develop your own unique style of drawing.

WORKING WITH PENCIL

The most commonly used drawing tool is the "lead" pencil – which is not actually made of lead but soft carbon graphite mixed with clay. Each grade makes a mark of a certain density; try them all to experience the quality of each grade. Larger sticks of graphite, not encased in wood, provide a broader point, and can be used on their side for covering large areas of tone or creating wide lines.

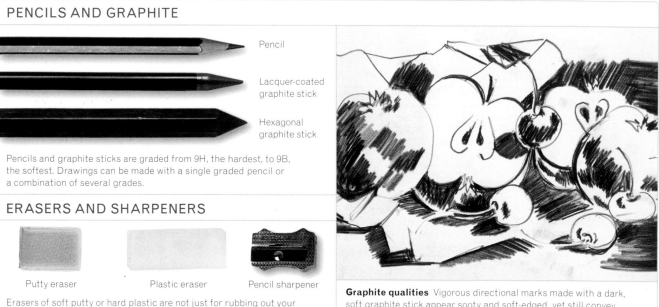

PENCILS AND GRAPHITE

Pencil

Lacquer-coated graphite stick

Hexagonal graphite stick

Pencils and graphite sticks are graded from 9H, the hardest, to 9B, the softest. Drawings can be made with a single graded pencil or a combination of several grades.

ERASERS AND SHARPENERS

Putty eraser Plastic eraser Pencil sharpener

Erasers of soft putty or hard plastic are not just for rubbing out your mistakes, but are drawing tools in themselves. Sharpeners or craft knives will give your graphite a fine drawing edge.

Graphite qualities Vigorous directional marks made with a dark, soft graphite stick appear sooty and soft-edged, yet still convey tremendous energy; the graphite medium infuses interest into this otherwise static still life.

COLORED PENCILS

Composed of pigment and clay, colored pencils are impregnated with wax to help hold the color to the drawing surface and prevent smudging. Colored pencils don't mix and so are made in a vast range of shades.

Marks made Smooth strokes and sensitive use of colored pencils can emulate the soft but intense colors of nature.

WORKING WITH PEN

Modern pens are readily available and are convenient to use in the field, as shown in the busy, spontaneous landscape below. Preloaded with ink and manufactured to consistent specifications, they make marks of predictable quality, though are available only in a narrow range of colors. Quill and dip pens need a separate ink source and make more haphazard marks.

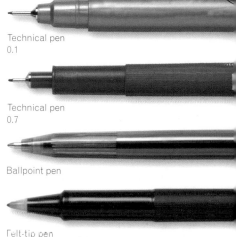

Technical pen
0.1

Technical pen
0.7

Ballpoint pen

Felt-tip pen

Technical and consumer pens make fine marks of constant width and quality; the width of the tips of technical pens is given in millimeters. Ballpoint and felt-tip pens are useful for spur-of-the-moment sketches.

WORKING WITH INKS

Inks can be applied with both brushes and nibs. Ink applied with a brush makes fluid calligraphic marks; drawing brushes are typically round and pointed, in contrast to the flat types used in oil painting, and are made from natural animal hair or synthetic fibers. Dip pens create characterful lines and can use almost any type of ink; fountain pens with an internal reservoir cannot be used with most Indian inks.

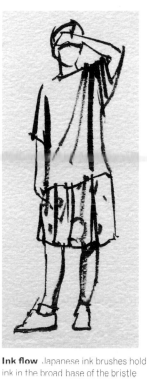

Types of ink Inks and liquid acrylics, which can be used in a similar way to inks, are available in a huge range of colors and can be mixed together to achieve almost any hue. Inks may be water-soluble or waterproof; India inks gain their waterproof qualities through the addition of shellac. Water-soluble inks can be "released" with water after they are dry to achieve tonal washes.

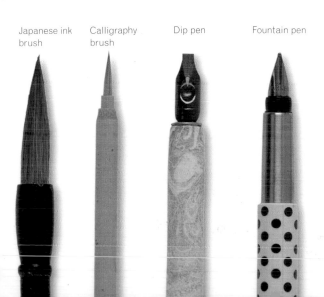

Japanese ink brush

Calligraphy brush

Dip pen

Fountain pen

Ink flow Japanese ink brushes hold ink in the broad base of the bristle head so that continuous lines can be made. Pens also have a specific ink flow varying from the irregular dip pen to the consistent fountain pen.

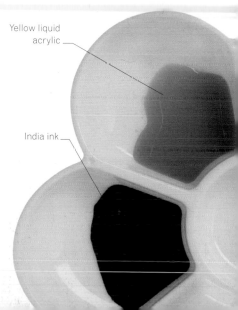

Yellow liquid acrylic

India ink

Charcoal and pastels

Soft drawing materials, such as charcoals and pastels, are capable of laying down broad areas of line and tone in both monochromatic and color drawings, making them particularly good for larger scale works. Colored pastels were very popular with the Impressionists who referred to their use as "dry painting." Their colors can be bold and brilliant – the word "pastel" does not imply paleness of tone.

USING CHARCOAL

Charcoal is usually made from willow vine or beech charred at a very high temperature. It can be readily erased and smudged allowing you to leave many traces in the drawing that reveal the mark of the hand that made it. Energetic, expressive drawings work well in this medium, as do images that require a wide range of broad strokes to depict large tonal areas.

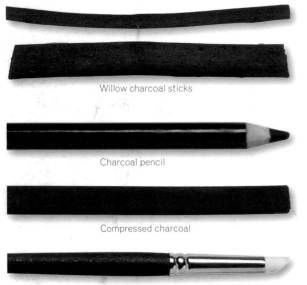

Willow charcoal sticks

Charcoal pencil

Compressed charcoal

Shaper

Charcoal drawing tools Willow charcoal is a brittle, powdery, and very tactile medium. Bound into a pencil or compressed – where charcoal dust is mixed with fine clay and a binder – it becomes more intense and more permanent. Charcoal can be smudged and dispersed with a fingertip or using a rubber-tipped shaper.

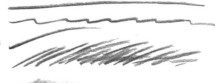

Charcoal marks
Fluid, vigorous, and smudged marks are the key drawing components of most charcoal works.

FIXATIVE

Fixative is made from resin dissolved in a colorless spirit solvent and usually sold in spray can form. It has a strong smell and is best used in a ventilated area. Fixative plays an important part when drawing in charcoal or pastel. It can be sprayed onto your work at regular intervals throughout the process, enabling you to fix areas of your drawing while it is in progress. It also acts as the final sealing layer for the preservation of your drawing.

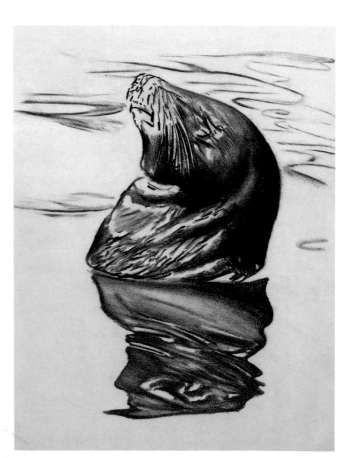

Seal head This drawing uses charcoal in a variety of ways: a few linear strokes indicate the surface of the water; broader, darker tonal areas describe the head; and rubbing back helps define the animal's reflection.

COLORED PASTELS

Pastels were developed in the 16th century, and their name comes from the French *pastiche*, meaning "mixture" or "paste." To make soft pastels, pure pigment is ground to a paste with a gum binder, then rolled into sticks. Other types of pastels are made by altering the nature of binder and quality of pigment used. Softer pastels tend to be encased in paper to preserve their integrity.

OIL PASTELS

Based on an oil or wax binder, these pastels produce thick, buttery marks reminiscent of oil paints. They can be used on oil painting paper and dissolved by adding turpentine to create soft and smudged color fields. They do not require treatment with fixative.

WATER-RELEASE PASTELS

These pastels are a relatively new innovation. They contain a water soluble component, such as glycol, which allows the colors to be released with a water wash to create a diffuse, ink-like quality in the drawing.

CONTÉ CRAYONS

Developed in the 1700s, these pastels are defined by their traditional earthy colors, such as sanguine, terracotta, and sepia.

PASTEL PENCILS

The wooden pencil-like casing of these soft chalky pastels makes them ideal for precise linear work, and for developing detail in a bigger drawing, especially in conjunction with larger chalk pastel sticks.

CHALK PASTELS

These pastels are made up of limestone with added pigment. They are tonally lighter than pure pigment pastels, offering you a subtle range of soft colors to work with. They require a fixative to prevent smudging.

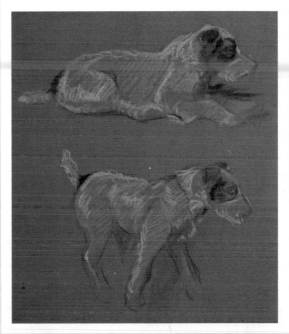

Textured paper is a suitable ground for pastel drawing because its "tooth" can hold the loose pigment. This simple drawing shows how effectively two tones – dark brown and white – can describe an image on a colored ground.

Paper

Paper is manufactured in an astonishing variety of weights, colors, textures, and finishes. Cheap, basic papers – ideal for quick sketches – are usually machine-made and based on wood pulp. They tend to degrade, becoming yellow and brittle. Art papers, based more on cotton and linen fiber, and made by machine or by hand, provide better drawing surfaces and archival qualities, though are more costly.

TYPES OF PAPER

Light, smooth papers are well-suited to delicate, detailed pencil work, but when working with mixed media, tonal graphite, or inks, it pays to choose a thicker ground. This will absorb any dampness, preventing buckling and wrinkling, and can be worked and erased more vigorously. Paper weight is expressed as weight (grams) per unit area (square meter); standard watercolor paper is around 300 gsm (grams per square meter) compared with office paper, which is 80 gsm.

Heavy art papers With a toothed surface, these robust papers are good for broad work in pastel and charcoal. The texture of the paper holds the crumbly pigment, enriching color or tone.

Decorative papers Small patterns on decorative paper can act as a backdrop to a bolder, stronger drawing laid on top; they can be used in collage or as underlay for a coat of gesso.

Drawing papers Basic drawing papers are available from hundreds of different paper mills. They are ideal for line work.

Watercolor paper

Indian handmade

Archival paper

ALTERNATIVE PAPERS

Unusual or specialized papers can broaden your creative horizons. Drawing on transparent acetate, for example, allows you to make marks that can be laid over other drawn or found images, while tracing paper can help you to lift elements from other images and incorporate them into your drawing. Envelopes, bus tickets, and postcards can all be drawn over, the essence of the ground contributing to your composition.

Experiment with paper The ground is as important as the medium in creating your desired effect.

Gridded papers Square or isometric graph paper sets out a template that can be followed or subverted.

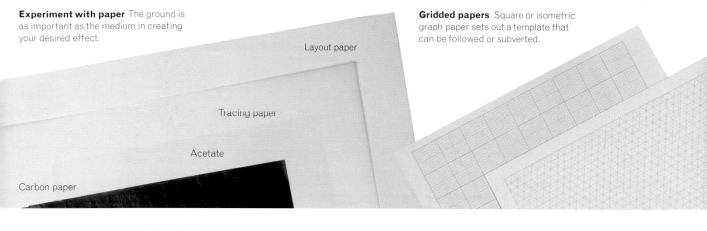

Layout paper

Tracing paper

Acetate

Carbon paper

SURFACE INTERACTIONS

The surface of a drawing paper affects the quality of the marks made on it. Specialized pastel papers are coated with pumice powder or cork particles that hold the colored pigment. Conversely, some hand-made papers have a satin finish so that a drawing medium, such as a fine pen, can glide over the surface without snagging. Others deliberately have inclusions, such as fibers or dry flowers, which affect the marks made.

TEXTURED PAPER WITH CHARCOAL

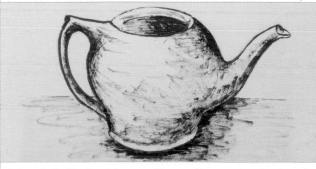

Charcoal on a rough textured paper will cling to the high ground of the paper and create a grainy drawing.

TEXTURED PAPER WITH PASTEL

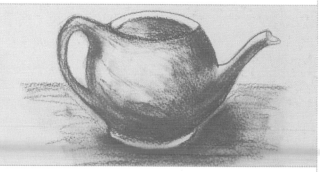

Colored pastel on a soft textured paper can be blended to produce solid areas and subtle tones and shadows that appear to glow.

SMOOTH PAPER WITH BRUSH AND INK

Ink applied with a brush to a smooth paper flows evenly; when dry, it imparts its own raised texture to the surface.

SMOOTH PAPER WITH PEN

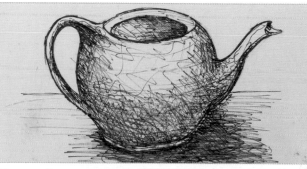

Fiber-tip pen imparts an even layer of ink to a heavy but smooth drawing paper, which can then be loosened with water.

Drawing research

Collecting ideas and visual references should be an ongoing activity for any artist. Think of your sketchbook as a visual diary – a place to make quick drawings from the world around you, and collect thoughts that will inform your future work. Take it with you wherever you go, pasting in text, images, and textured papers and objects to build up your own personal library of inspiration.

SKETCHBOOKS AND FOLIOS

The sketchbook is a place to "play" and experiment without fear (even van Gogh's sketchbooks contained "mistakes"). Sketchbooks come in many forms and sizes; the cheapest notebook will do, but many artists prefer to use books made up of fine drawing papers. A thrifty alternative is to select the papers on which you like to draw and have them comb-bound into a book.

Buy the book Your sketchbook is your friend, whether it is an expensive marbled volume or a simple pad.

Small portfolios These folders are very useful for collating and keeping loose themed sketches.

LOOSE PAPER SKETCHES

You learn to draw through making mistakes; to make lots of mistakes, you need to make lots of drawings. Get into the habit of drawing whenever you can, on whatever surface is available – there's no substitute for trial and error.

Everyday stationery The rough surface and buff color of this stationery works well to support the immediacy of ball-point pen drawings.

Wrapping paper Patterned wrapping paper creates a lively rhythmic support for a colorful pastel drawing.

USING SKETCHBOOKS

There is no right or wrong way to use your sketchbook. Some artists use them principally to experiment with drawing processes, others to record their observations, much as a journalist uses a notebook, others still to initiate and develop ideas for a specific project. Many keep several sketchbooks, each related to a different theme.

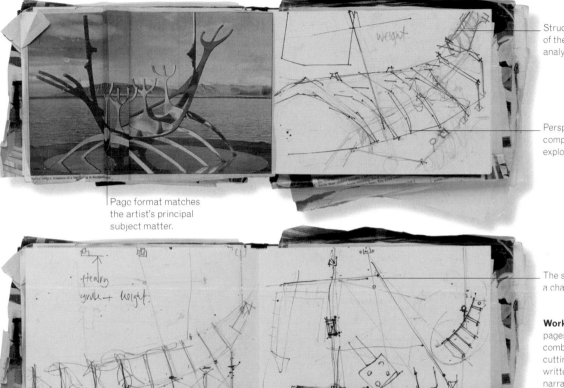

Structural elements of the photograph are analysed in sketches.

Perspective and composition are explored.

Page format matches the artist's principal subject matter.

The sketch becomes a character study.

Working direction The pages of this sketchbook combine magazine cuttings, drawings, and written notes into a strong narrative. The result is a suite of references to be used in a final drawing.

Travel sketchbook There is a long tradition among artists for recording journeys as visual diaries. Use your sketchbook to record fleeting moments and expressions; paste in souvenirs and visual references that represent aspects of the place or culture you are engaging with.

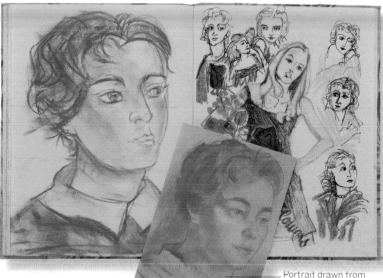

Portrait drawn from sketchbook reference.

Preparing to draw

Drawing requires your full attention, so minimize distractions by carefully preparing your working environment. Whether you are working on a wall, at an easel, or on a tabletop, make sure your space is well-lit, and that you have enough room to move freely. It also pays to experiment with the media you have chosen to become familiar with their particular mark-making characteristics.

MATERIALS AT THE READY

Gather together your research notes and sketches, and lay out all the materials you are likely to need for your drawing session. You may find that the ritual of laying out your tools will help to focus your mind on the job in hand. Your drawing tools should be sharp and clean; keep them close at hand, organized by type – so that pastel pencils are separated from graphite, for example.

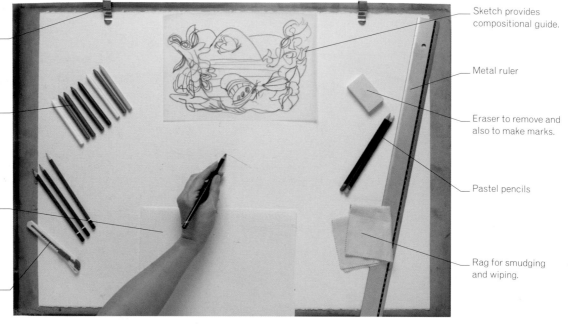

Clips or tape hold the paper securely to the drawing board.

Sharpened color pastels

Scrap paper laid over work prevents unwanted smudging.

Craft knife for sharpening tools or cutting out collage elements.

Sketch provides compositional guide.

Metal ruler

Eraser to remove and also to make marks.

Pastel pencils

Rag for smudging and wiping.

SCALE ISSUES

Drawings smaller than A3 (11.7x16.5 in) size can comfortably be completed while you are seated at a desk; larger drawings should be made standing, with the paper attached to an easel or a wall. This will enable you to reach all parts of the drawn area without stretching, giving you full control over the marks you make, and also eliminate any distortion introduced by the low viewing perspective when drawing seated.

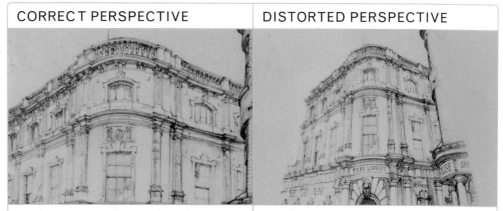

CORRECT PERSPECTIVE

Drawings of buildings are vulnerable to distortion caused by the working position. Created on an easel, this large-scale drawing displays correct perspective.

DISTORTED PERSPECTIVE

If the finished drawing is viewed on a table, it seems to recede; when working seated, you will naturally compensate for this recession, creating distortion.

MAKING YOUR MARK

The sensitivity of mark making affects the character and energy of a drawing. You will gradually develop your own repertoire of mark making styles through trial, error, and experience, and the reward will be greater freedom in your drawing practice. Whenever you buy new drawing tools, test the precise quality of their marks, and assess their suitability for your style.

PASTEL AND PEN MARKS

Rolling a pastel stick across the paper leaves an uneven, almost organic mark, very well suited to drawing natural forms.

Pushing a pastel across the surface leaves a tapered mark that can imply recession into the distance away from the point of origin.

Cross-hatching with an ink pen creates an even yet lively tonal surface. Repeated passes can represent the densest shadows.

Swift rhythmic movements with the edge of a pastel suggest energy and pick out the high ground of the paper, adding surface interest.

Dragging a pastel swiftly across the surface produces a dynamic mark suitable for applying broad swathes of tone.

Brush drawing with ink leaves a clear, precise, and fluid line with no jagged edges – perfect for gestural drawings.

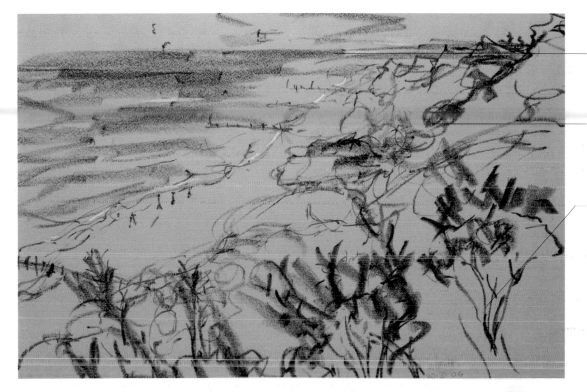

Used on its side in bold, horizontal strokes, pastel quickly evokes a dark sea horizon.

Wild shrubbery is described though a collection of twisted pastel marks.

Strong horizontal inward strokes lead the viewer's eye inward from the edge of the composition.

Coastal scene
A variety of pastel mark marking techniques has been used in this highly charged drawing, which captures a range of textures and directional dynamics.

Measuring and mapping

Getting the proportions of a subject right, and correctly representing the relationships between objects, are fundamental to the success of any representational drawing. This is particularly true of life drawing, where errors in the basics become ever more noticeable as the drawing progresses. Measuring and mapping before drawing is not essential, but it will help you avoid many lengthy redraws.

MEASURING THE HUMAN FORM

You don't need a ruler to measure the proportions of your subject. A simple technique is to use a pencil, held at arm's length from your eye, to measure the length of the model's head, from the top of the crown to the base of the chin. This head-length then becomes the basic unit of measurement for all parts of the body, for example, a standing figure is around seven heads high.

USING A PENCIL TO MAP PROPORTIONS

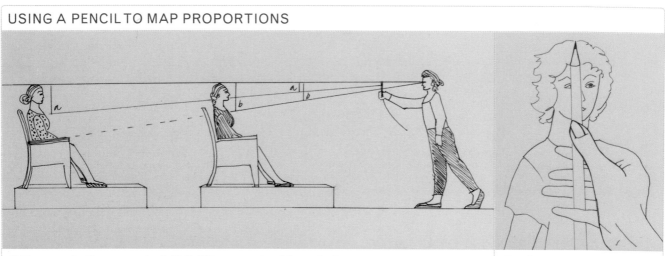

Hold up a pencil with your arm extended fully. With one eye closed, line up the tip of the pencil with the top of the model's head; use your thumb to mark the bottom of the chin. Be sure to take any further measurements from exactly the same spot.

Transfer your measurement to your drawing; you can use a similar technique to measure angles too.

FRAMEWORKS FOR THE BODY

Draw two axes at right angles, and plot the positions of key points – joints of limbs – relative to the axes.

Check the distances of joints and limbs both from your axes and from one another.

Use multiple faint lines to build up the scaffold of the body and find its form.

Once you are sure of the sizes and relationships of the elements, strengthen the lines.

RELATIONSHIPS AND COMPOSITION

Whether you are working with a model or a still life, the placement of your subjects on the paper is key to success. Closely analyze which part of a subject lies in front of or overlaps another – things are not always as they seem at first glance.

Measure relative sizes with a pencil, and check this on the paper by looking closely at the negative spaces that emerge between items and forms – are they the right shapes? Use convenient verticals to check angles within the drawing.

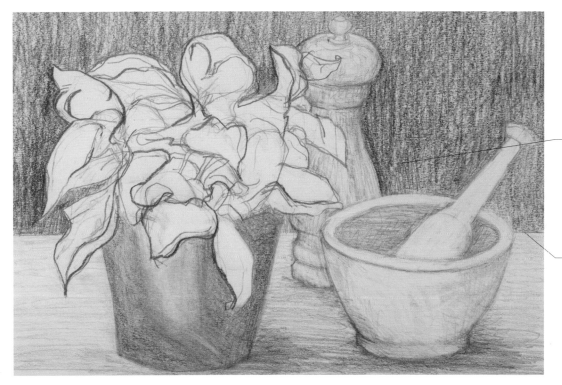

Still life Placement of objects close to the edges of the paper creates the illusion that they are protruding from the plane of the drawing.

Directional marks make the vertical shading of the background distinct from the horizontal marks used for the foreground.

Vertical and horizontal elements in the scene – here a table – are a useful reference for assessing angles and relative positions.

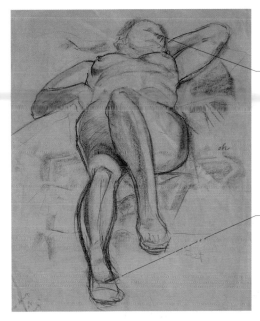

Faint lines suggest distance.

Feet are commonly drawn too small in a foreshortened pose.

Foreshortening Accurate measurement is particularly important when dealing with the reclining – and therefore highly foreshortened – human form. Keep checking the relationships between elements as you draw.

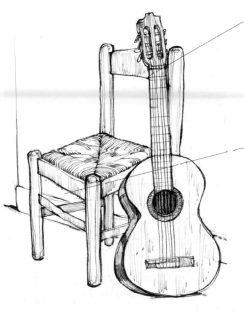

Dynamism in the drawing is created by mixing strong verticals and curves.

Negative space between the chair legs.

Negative space This deceptively simple drawing explores complex planar relationships. Examining the negative spaces between the elements enables you to unravel the jumble of elements

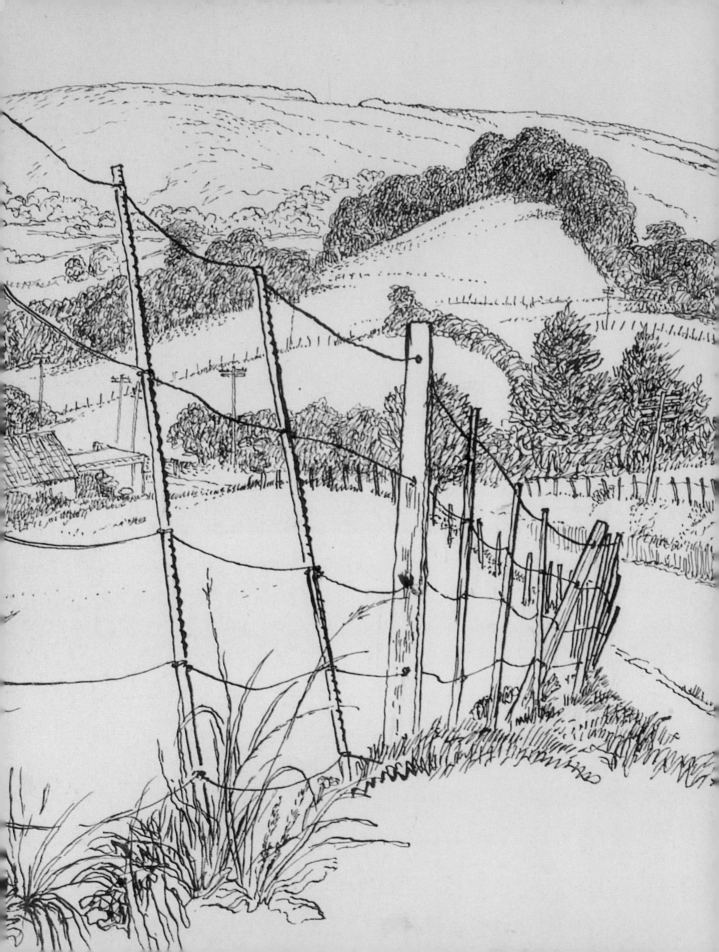

"The classic scene, the city,
and the imagined paradise
all provide rich inspiration."

Perspective

Perspective (from the Latin word for "to see") is a formal system for representing three-dimensional objects on a flat surface in a way that appears natural to the viewer. It is an illusion in which objects are drawn ever-smaller as their distance from the observer increases, and straight-edged objects are distorted according to geometric principles to make them appear realistically three dimensional.

POINTS OF VIEW

The use of perspective is best demonstrated with simple rectangular blocks. The front face or edge of the block is drawn first; its other lines are then added so that they recede from the viewer and gradually approach one another – just as they seem to do when you look at a real object. If extended beyond the object these receding lines eventually meet at "vanishing points."

ONE-POINT PERSPECTIVE

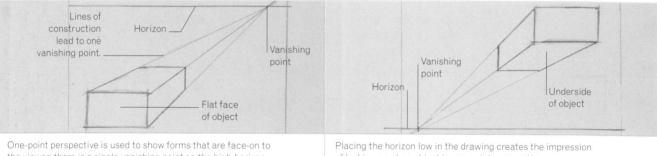

One-point perspective is used to show forms that are face-on to the viewer; there is a single vanishing point on the high horizon.

Placing the horizon low in the drawing creates the impression of looking up at an object in one-point perspective.

TWO-POINT PERSPECTIVE

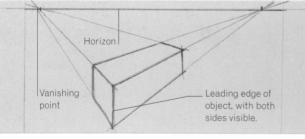
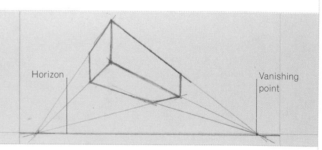

Two-point perspective depicts an object at an angle. There is one vanishing point for each set of parallel lines in the object.

A low horizon combined with two-point perspective; two sets of construction lines lead to two vanishing points.

HIDDEN VANISHING POINT

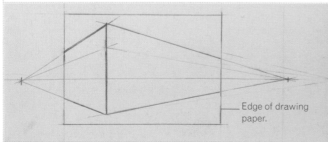

In some drawings, the vanishing points may be off the page; construction lines may still help with building the image.

REAL-LIFE PERSPECTIVE

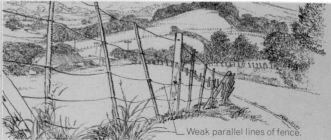

Vanishing points only occur if parallel lines are present in a scene. Many natural scenes have no – or only weak – parallel lines.

THE DEVELOPMENT OF PERSPECTIVE

Geometric perspective as used today was developed in Italy in the early 1400s, when Renaissance artist Filippo Brunelleschi painted the outlines of buildings on to mirrors, and observed that all the lines converged on the horizon. Before this innovation, the main method of showing distance was to overlap forms, which made for very poor architectural drawings.

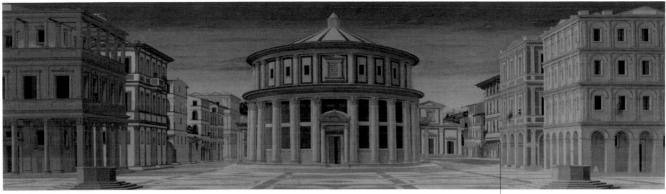

Theory into practice Piero della Francesca, the Renaissance mathematician and artist, based his works on his theoretical studies of perspective.

Strong one-point perspective gives the image striking depth.

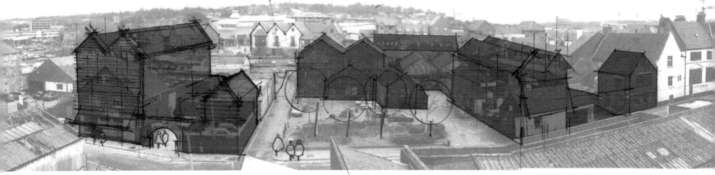

The drawing is combined with a photographic image to give a real sense of place.

Complex perspective Impressive depictions of the built environment can be made with a good understanding of perspective.

The structure of the building is completely revealed in this axonometric projection.

Axonometric drawings allow architects to measure directly from the drawing, knowing that the scale is correct.

Axonometric drawing Ignoring the foreshortening effects of perspective can result in an axonometric drawing, where verticals and horizontals are drawn to scale regardless of their distance from the viewer. The technique is widely used by architects.

Partial transparency reveals the structure of the building.

Color in space

Before the advent of linear perspective, artists used color to suggest scale; bright figures and objects were read as being close, and therefore important in the composition. Color, combined with formal perspective, still plays a vital role in establishing depth. Color has a direct psychological effect on the viewer in which warm colors appear to advance, while cooler blues and greens appear to recede.

ADVANCING AND RECESSIVE COLORS

Color combinations can create or subvert the illusion of depth and space. The two pastel drawings below are identical in composition. The upper drawing has a strong sense of relief while the lower drawing becomes a flat abstract pattern without obvious dimensionality. The difference lies exclusively in the choice of color and positions of tones.

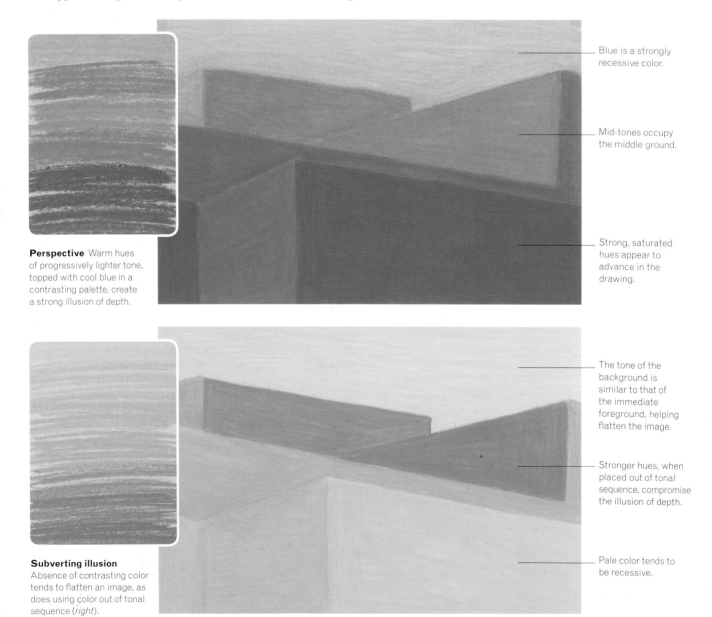

Blue is a strongly recessive color.

Mid-tones occupy the middle ground.

Strong, saturated hues appear to advance in the drawing.

Perspective Warm hues of progressively lighter tone, topped with cool blue in a contrasting palette, create a strong illusion of depth.

The tone of the background is similar to that of the immediate foreground, helping flatten the image.

Stronger hues, when placed out of tonal sequence, compromise the illusion of depth.

Pale color tends to be recessive.

Subverting illusion Absence of contrasting color tends to flatten an image, as does using color out of tonal sequence (*right*).

COLOR AS SUBJECT

For pre-Renaissance artists, color was used to ascribe spiritual value to a subject; prized pigments, such as ultramarine, vermillion, and gold were used not for decorative effect, but to directly reflect God's glory. This highly symbolic use of color created its own order within the work. Many recent artists too have focused on color as the subject of their work; a notable example is the American artist Mark Rothko, whose non-representational color compositions are charged with emotion.

Blue appears recessive, even in abstract composition.

Red verticals appear to push forward from the plane of the paper.

Layers of colored pastel give depth to this abstract composition; textures implying solidity contribute to the reality of this invented space.

Background figures are the same size as those in the foreground.

The absence of linear perspective is no barrier to creating an illusion of depth. A hierarchy is conjured up in this medieval work by the use of warm red and skin tones against recessive blues and violets

The importance of figures in medieval art was reflected in the cost of the pigments used to depict them.

Clear iconic images send a direct religious message.

Composition and illusion

The illusion of depth created by linear perspective and reinforced through the use of color can be further enhanced by compositional sleight of hand. The frame that a drawing sits within is not just an embellishment, but presents another plane to the viewer and defines the positive and negative spaces within the piece. Frames created within the drawing will similarly influence the perception of depth.

INTERNAL FRAMES

Take some time to study a scene before establishing your viewpoint. Natural frames – such as a doorway, window, a gap in foliage, or even a shadow cast by an object – will launch the eye on an imaginary journey to the back of the drawing. Reference points – objects encountered along this journey – establish successive planes within the drawing.

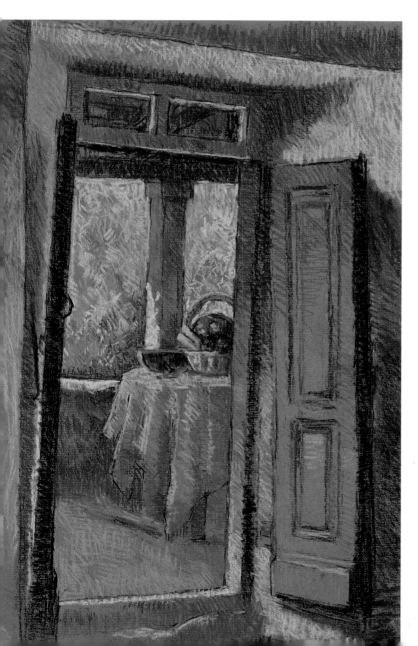

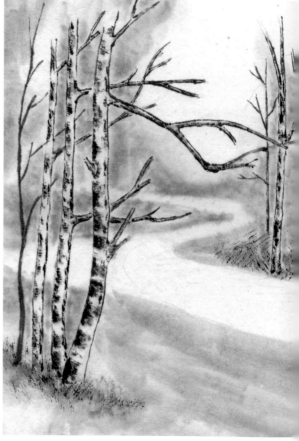

Japanese ink drawing A clear frame in this drawing is established by the bare branches of the birch tree in the foreground. The road, which narrows towards the horizon, eventually vanishing into the misty background, reinforces a sense of movement through a scene.

The space beyond An open door is a clear cue to explore beyond the foremost plane of this drawing. Three further planes established by the table, the column, and the recessively-colored foliage create the illusion of a real physical space.

FRAMING AND PRESENTATION

Mounting and framing a drawing will protect it from damage and enhance its presentation, but also plays a role in defining the meaning of the work. A cut mount placed over a landscape is literally a window on to the world you have depicted and so naturally imparts a further sense of perspective. The difference a mount can make is evident in the drawings below.

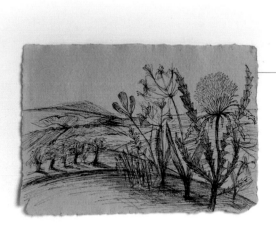

Floating mount The quality and color of the hand-made paper support the image; the visible rough edges of the paper impart a natural quality that references the drawn scene.

A floating mount casts a small shadow, pushing the drawing toward the viewer.

The drawing flows naturally to the edge of the paper.

CUTTING A MOUNT

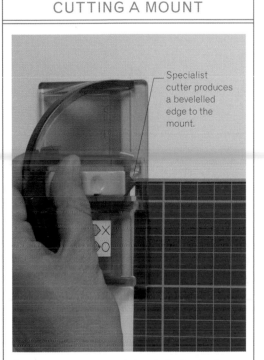

Specialist cutter produces a bevelled edge to the mount.

Cutting your own mounts is relatively simple, but requires a little practice and good tools. You will need a cutting mat, a steel ruler, and a specialized cutter with its blade at a 45° angle.

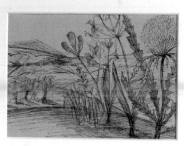

Window mount The beveled edge of the cardboard mount creates a "step" into the drawing. By taking this step, the viewer becomes complicit in the illusion. The mount tightens the presentation and keeps the glass of the frame away from the drawn surface.

The drawing is trapped by the mount edge.

inspiration that changes with the seasons and the time of day.

▶ Railway Yards at Moret-sur-Loing

The atmosphere of a snowy day is captured perfectly by pastel marks, laid down on the paper in the same way that the snow rests on the land. The subject and the process are perfectly matched to create a harmonious drawing. *Alfred Sisley*

▼ Gate with wire

Fine pen and ink work captures the intricate detail of the foreground. The eye is drawn through the fence to the woody horizon, while the space left around the central area of the drawing alludes to the spaciousness of the open countryside. *Unknown, Norwich School of Art and Design Drawing Archive*

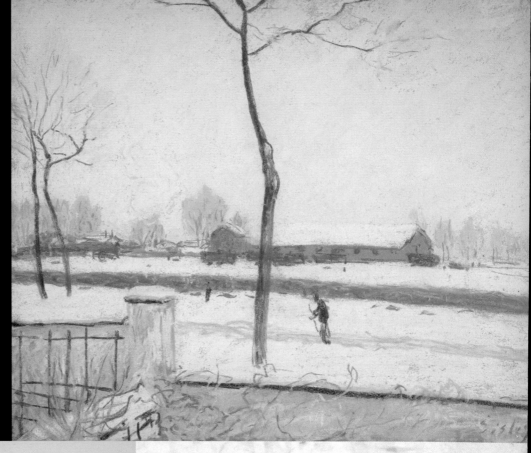

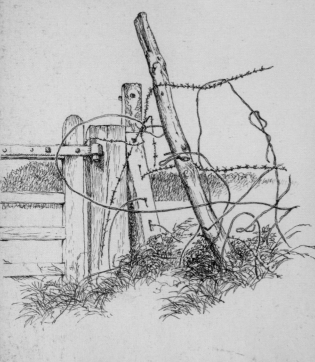

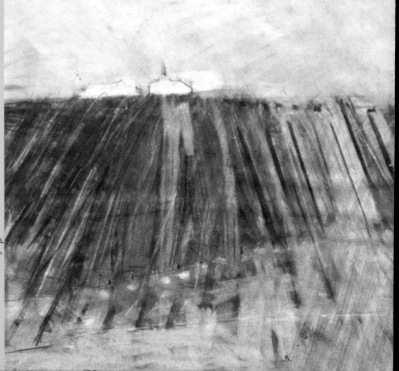

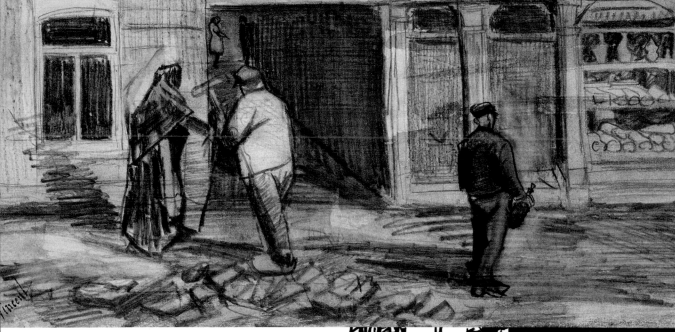

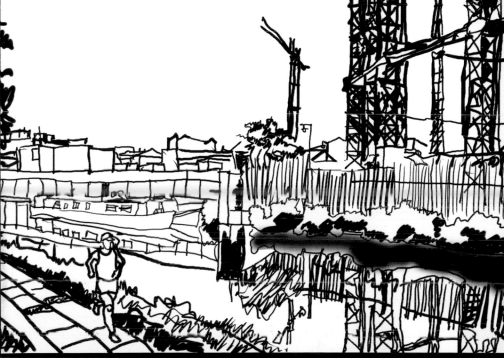

▲ The Bakery in de Geest

This vigorous pencil and charcoal drawing on textured paper has a raw intimate quality. The eye is drawn to the shop only after engaging with the strongly drawn characters in the foreground. *Vincent Van Gogh*

◀ The jogger

Digital drawing processes add a contemporary touch to this line drawing of an urban landscape. Strong horizontal and vertical lines and patterns contribute to the energy of the piece. *Emily Cole*

◀ Plowed field

This deceptively spontaneous drawing is actually the result of much searching. The artist has applied successive layers of charcoal followed by positive erasing through the surface: the sky has been erased back to white from black, contributing to the glittering quality of the light. *Andrew Gibbs*

1 Art deco building

This drawing is an exercise in one-point perspective (*see p. 26*) in which dynamic mark making is used to evoke a powerful architectural structure. The starting point is a photograph of an art deco building, taken from a deliberately low viewpoint to inject strong perspective into the composition. The building's form emerges from tone rather than line detail and the drawing is not intended to be overly representational; the tone is created through the bold use of graphite sticks and pencils.

EQUIPMENT

- Heavy white drawing paper
- Tracing paper
- 3B pencil and ruler
- 6B and 9B graphite sticks
- Plastic eraser

TECHNIQUES

- Using one-point perspective
- Creating tone and reflections in graphite
- Using an eraser as a mark-making tool

SKETCH THE COMPOSITION

Traced verticals converge, giving perspective.

Lay a sheet of tracing paper over your photograph and draw over the building's key outlines with the 3B pencil. The tracing distills the lines that create perspective and is a useful reference when you begin your drawing.

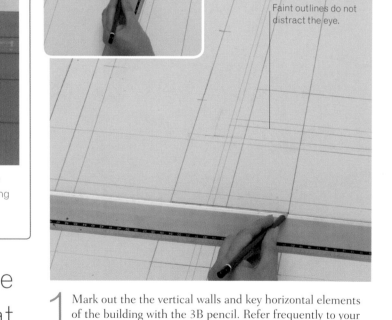

Faint outlines do not distract the eye.

"Match your media to the content: graphite is great for tough, solid forms."

1 Mark out the the vertical walls and key horizontal elements of the building with the 3B pencil. Refer frequently to your photograph and to your tracing of its key outlines – it is important to get the perspective right before you start to add tone to the drawing. Use a ruler for the straight lines.

BUILDING THE IMAGE

2 Continue mapping out the principal horizontal lines in the composition using the ruler for the straight edges. Indicate the positions of the windows along the vertical lines with faint dashes. Put your reference tracing to one side and begin working directly – and much more freely – from the original photograph.

TONE IN GRAPHITE

Try not to get bogged down in detail – the essence of graphite drawings is laying down the correct densities of tone.

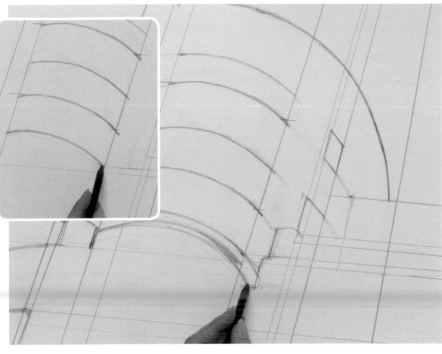

3 Establish the curved forms of the building's tower with the 6B graphite stick. Draw the curves smoothly, pivoting your wrist from where it rests on the paper, using your hand like a compass. Rub out the vertical pencil guides that extend above the building to clearly delineate the areas that need to be shaded.

4 Begin adding tone with the 6B graphite stick. Work with light pressure, following the shape of the building with the movement of the graphite: use curved shading marks for curved structures and vertical marks for upright elements.

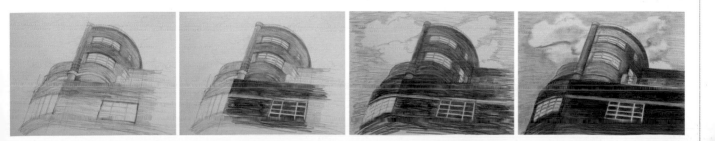

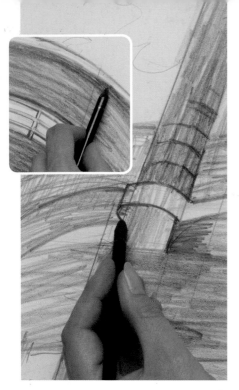

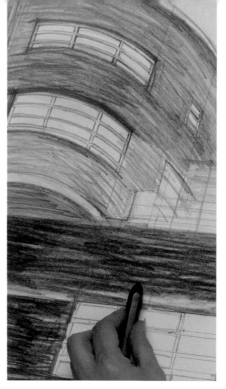

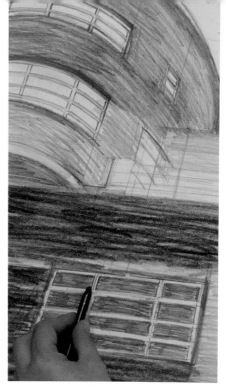

5 Sketch in the outlines of the clouds and start to add heavier shading to define form in the building. Darken the shadow areas beneath the roof and around the columns.

6 Work heavily with the 9B graphite stick to lay down tone in the densely shadowed parts of the building. Use the side of the graphite – there's a large area to cover with tone.

7 Darken the reflection in the lower window with the 6B graphite stick; rub back the window frames with a fine eraser – such as one on the end of a pencil – to accentuate contrast.

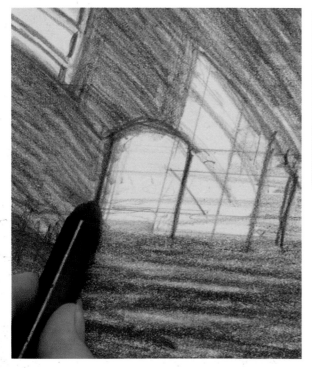

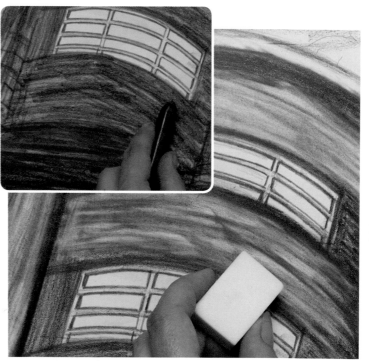

8 Use bold graphite marks to re-establish the outline of the building and to introduce details – such as the railings along the balcony. Create prominent lines that stand out from the overall tone of the drawing to give an immediate sense of depth.

9 Build up layer upon layer of tone, and keep re-establishing line detail. Decide when the graphite is as dark as it needs to be, then selectively rub back areas with the plastic eraser; this subtractive process brings out the reflective quality of the surface – almost impossible by using only additive processes.

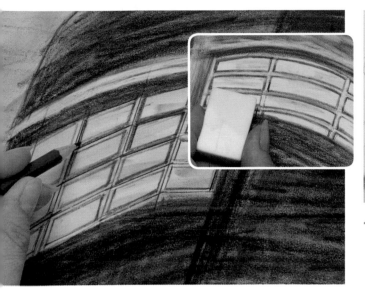

11 Add soft, filamentous lines into the sky areas with the 9B graphite stick. Rub in and blend the marks, using your fingertip to create the wispy edges of the cloud. Use stronger, directional lines to indicate the darker sky – there's no need to be rigidly representational here.

10 Reinforce the lines of the window frames using the sharpened 3B pencil. Smudge and blend tone, and take tone away, using the plastic eraser – carefully control the pressure to lift the tone selectively. Use the dirty plastic eraser to add smoky tone into the window areas to suggest the reflections of cloud.

▼ Art deco building

Both line and tone in this drawing have been built up by applying and then rubbing back the graphite medium. This repeated process is the only way to create a richness in the graphite drawing that effectively alludes to the complexity of real forms.

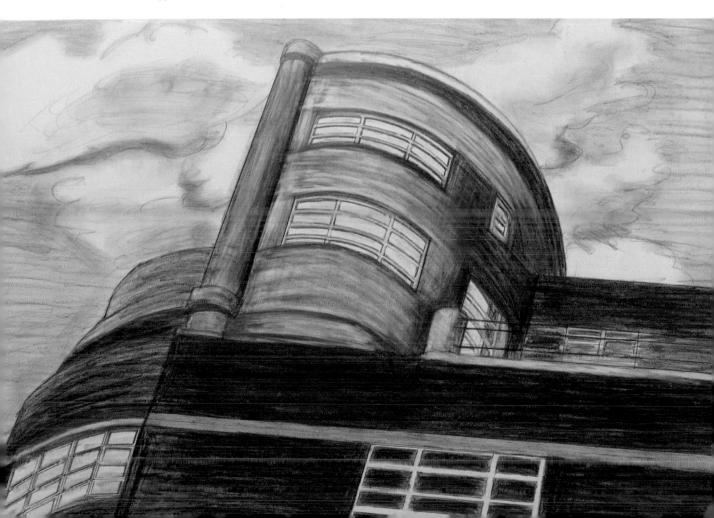

2 Venetian vignette

Playing with the relationship between drawing and illusion, this whimsical project echoes the decorative silhouettes and vignettes of the Victorian period. Executed in water soluble blue ink, it relies on spontaneous gestural lines to portray a Venetian scene. Layered crosshatching depicts solid form, while wash applied with a brush provides a watery tone consistent with the subject matter. The drawing is finished by a decorative "frame" stenciled onto the paper with a colored pastel, giving the impresssion of a porthole into a romantic age.

EQUIPMENT
- White drawing paper
- Thick cardboard
- Craft knife
- HB pencil
- Fine and medium blue water soluble fiber tip ink pens
- Fine sable brush
- Plastic eraser
- Ocher chalk pastel stick
- Aerosol fixative

TECHNIQUES
- Haystacking (layered hatching) to create tone
- Releasing color

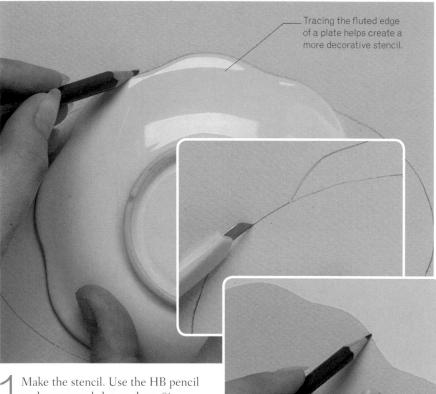

Tracing the fluted edge of a plate helps create a more decorative stencil.

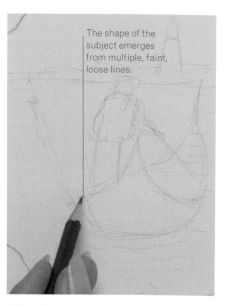

The shape of the subject emerges from multiple, faint, loose lines.

1 Make the stencil. Use the HB pencil to draw an oval shape, about 8in (20cm) across its long axis, onto the thick cardboard. Embellish the top and bottom of the oval by drawing around a fluted plate. Cut out this shape with a knife, then trace around it onto the paper to make the stencil.

2 Sketch the Venetian scene working within the outline you have drawn. Use light, gestural lines; make multiple marks until you are happy with the basic outline. Note how the repetition of vertical forms – the prow of the boat and the lighthouse – creates the illusion of distance.

BUILDING THE IMAGE

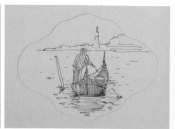

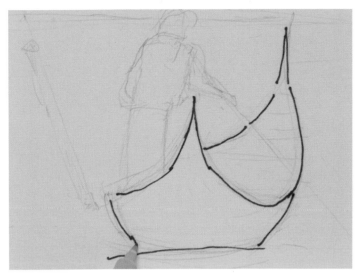

3 Begin to draw over the pencil outline. Start with the fine ink pen – a fine line can always be made heavier, but a thick line is there for good. Keep your hand loose – you are using the pen as a drawing, not writing, tool.

4 Draw the figure of the gondolier, allowing the lines to wander a little to capture the dynamism of the pose. Pay careful attention to the weight distribution in the body – remember that the gondolier is pushing against the pole.

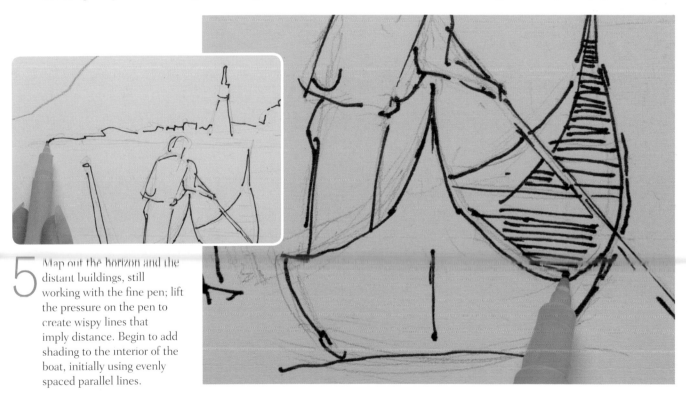

5 Map out the horizon and the distant buildings, still working with the fine pen; lift the pressure on the pen to create wispy lines that imply distance. Begin to add shading to the interior of the boat, initially using evenly spaced parallel lines.

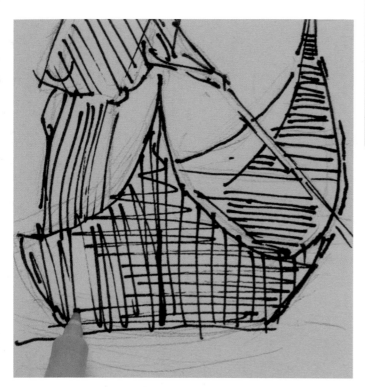

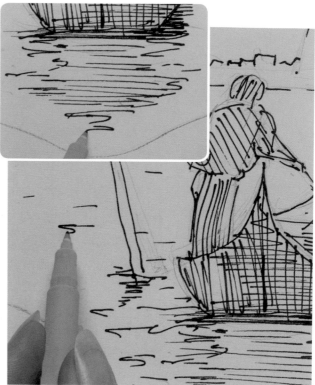

6 Continue shading the boat and figure with directional lines – vertical for upright elements like the legs, and diagonal for the torso, to suggest motion. Start building denser tone in the boat by crosshatching the darker shadow areas.

7 Draw the water using S-shaped string-like marks to represent the way in which the water eddies in the wake of the boat, and short wavy horizontals to represent the wavefronts.

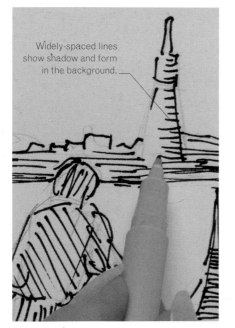

Widely-spaced lines show shadow and form in the background.

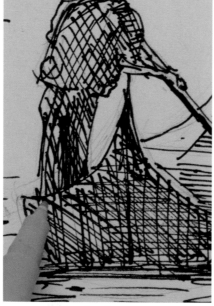

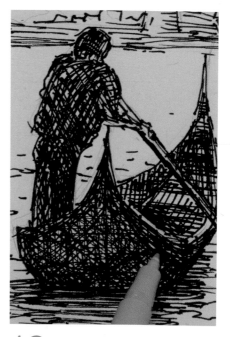

8 Make horizontal marks to add tone to the background. Use the fine ink pen, and keep the lines well spaced. The lighter background that results will appear to be recessive in the finished drawing.

9 Gradually build up layer upon layer of crosshatching at different angles – a technique sometimes called "haystacking" – to darken both the boat and figure, which appear as near-silhouettes.

10 Add the densest tones using the medium ink pen, filling in only the deepest shadows completely with ink. Selectively leave highlights to show the direction of incident light.

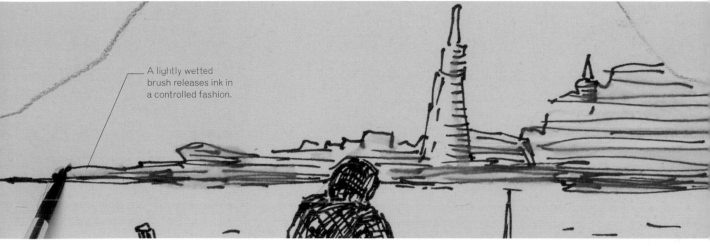

A lightly wetted brush releases ink in a controlled fashion.

11 Wet a fine sable brush with clean water and begin painting the wash over the background marks to release the pigment from the ink. Work along the lines of hatching, not across them, so that the color diffuses gently, giving a faint misty effect.

"Variations in tonal density help establish perspective."

12 Apply the water wash to the figure and the boat. Don't soak the brush – the ink is very soluble and releases easily. Aim to retain some of the surface texture of the crosshatching, rather than creating a solid, uniform block of tone.

PAPER CHOICES

When working with a fine pen, choose a paper surface that is firm and smooth: the tip of the pen should not snag on any bumps.

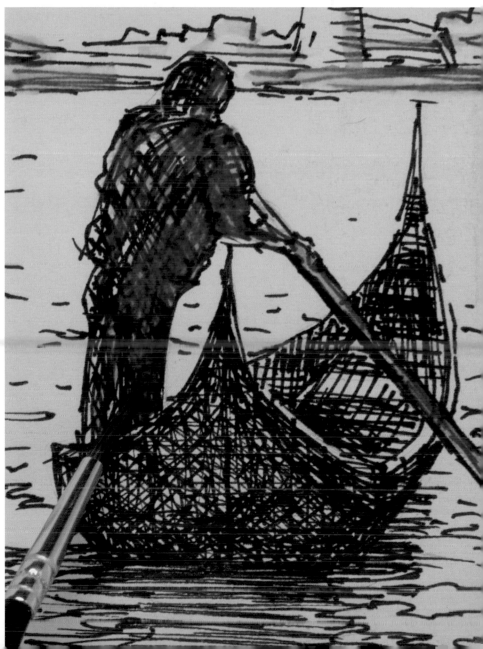

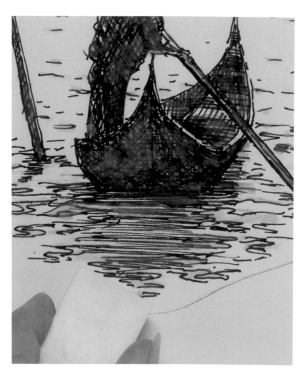

13 Apply the wash to the water areas. Follow the swirling S-shapes with the tip of the brush, releasing color from the ink to create a translucent quality in the water. Allow the wash to dry for 30 minutes.

14 Use a plastic eraser to remove most of the pencil outline. Retain faint traces of the pencil at the top, bottom, left, and right of the drawing so that you can accurately position the stencil.

Pressing hard on the pastel next to the stencil creates a crisp edge.

15 Carefully line up the stencil with the remaining pencil marks. Work around the stencil heavily with the ocher chalk pastel. Keep the edge of the stencil pressed flat onto the paper.

16 Work with the side of the pastel stick to quickly fill the area around the stencil with flat color. Do not allow colored dust from the pastel to get under the stencil – it will bleed into the picture area.

17 Rub the pastel with your fingertips to blend the color. Work away from the edge of the stencil outward. Carefully blow the excess pastel dust away from the stencil.

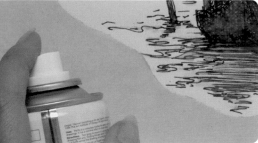

18 Gently lift the stencil from the drawing, ensuring that the pastel dust does not fall on to the image. Spray the drawing with a fixative to prevent the pastel from smudging.

▼ Venetian vignette

In this piece, ink combines with wash to create an atmospheric drawing, perfect for capturing travel memories. The stenciled frame draws the eye to the background, adding to the sense of depth.

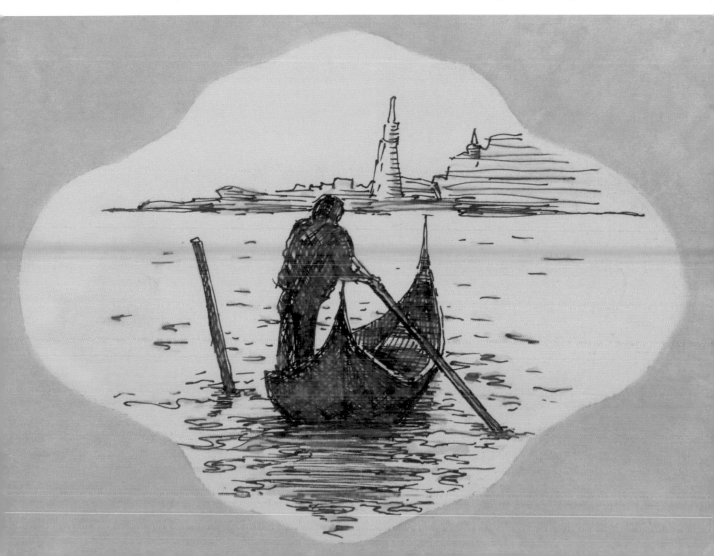

3 Tropical scene

This colorful creation of a tropical scene is pure artifice, compiled from several different reference sources rather than a single photograph. The drawing is all about form, rhythm, and color, and is made up only of lines produced with water soluble crayons. The lines emphasize the curved, sensual shapes of the natural forms and separate them from one another. Using water to release pigment in the final stage of the drawing creates interest in the surface texture, and is always exciting for its unpredictable effects.

EQUIPMENT

- Heavy off-white watercolor paper
- HB pencil
- Ruler
- Plastic eraser
- Good quality medium sable brush
- Olive green, magenta, lavender blue, sea blue, emerald green, cadmium red, lime green, and light powder green water soluble crayons

TECHNIQUES

- Using colored line to separate objects
- Releasing color from water soluble crayon

SKETCH THE COMPOSITION

Collect reference for the drawing from books and magazines; look for bright, rich, inspirational colors consistent with the tropical theme. Sketch some compositions using the colored crayons – the drawing relies so heavily on the relationships of colors. It helps to think about elements occupying layered planes in the drawing so that contrasts between colors and levels of detail can be used to convey perspective.

1 Draw the outlines of the main forms with an HB pencil. Adjust the composition, accounting for the fact that the reference photos were taken from different angles and under different lighting conditions. Begin working over the outline of the large flower to the right with the olive green crayon.

Variations in the pressure of the crayon give the line personality.

BUILDING THE IMAGE

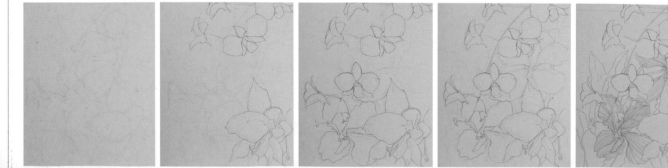

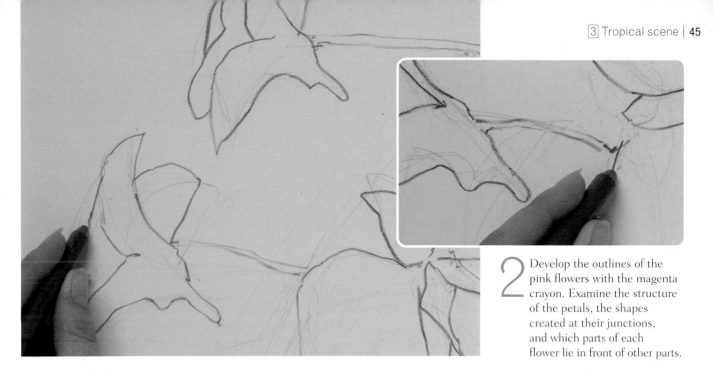

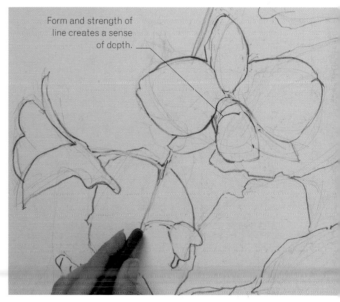

2 Develop the outlines of the pink flowers with the magenta crayon. Examine the structure of the petals, the shapes created at their junctions, and which parts of each flower lie in front of other parts.

Form and strength of line creates a sense of depth.

"Allow the drawing to run away with itself – one line should guide the next."

3 Use the lavender blue crayon to map out the principal lines of the blue flowers. These flowers constitute the background of the drawing, their recessive colors focusing attention on the red and magenta foreground flowers.

4 Draw the plant stems that join together the magenta flowers with the tip of the olive green crayon. Keep the presure firm at first, then release it to taper the line as it recedes away from the foreground.

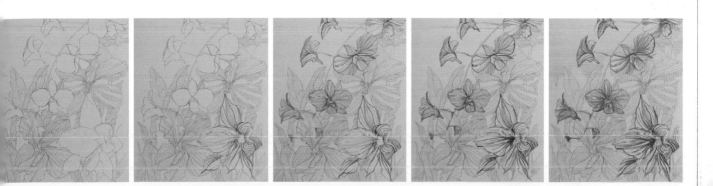

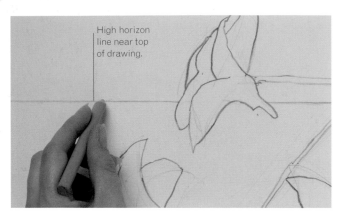

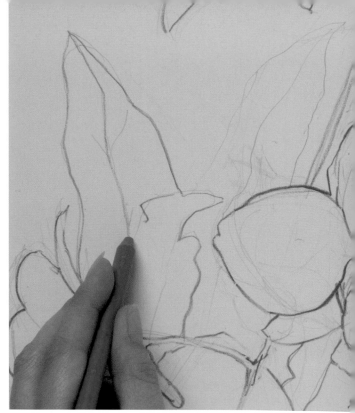

5 Draw a line to indicate the horizon line with the HB pencil and ruler. Place the line so that it does not appear to merge into the outline of a flower and then draw over the pencil line with the sea blue crayon.

6 Outline the leaves with the emerald green crayon. Add their midribs to create a vertical dynamic in the drawing that contrasts with the curved forms of the flowers; combining linear and rounded shapes adds to the sense of space.

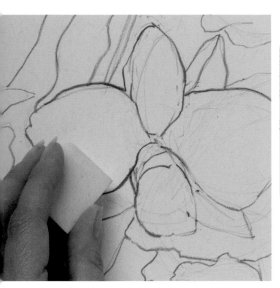

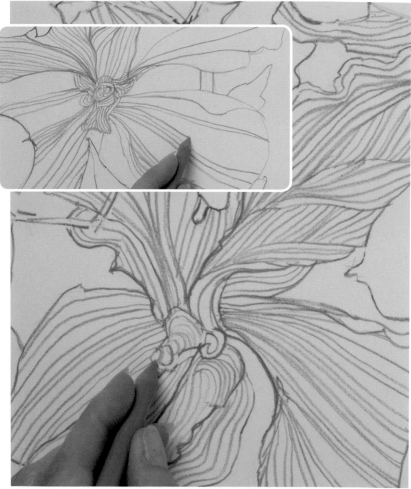

7 Rub out your pencil underdrawing with the plastic eraser once you have captured the outlines of the main forms. The image is based on pure color – even faint gray lines would compromise its vibrancy.

8 Begin adding color to the petals using the lavender blue crayon. Examine and exaggerate the structures inherent in the natural forms. Start with a few key curved lines, and then gradually add more lines in between to build the forms.

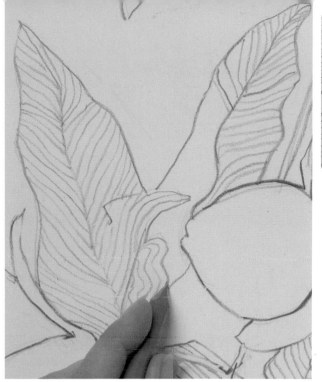

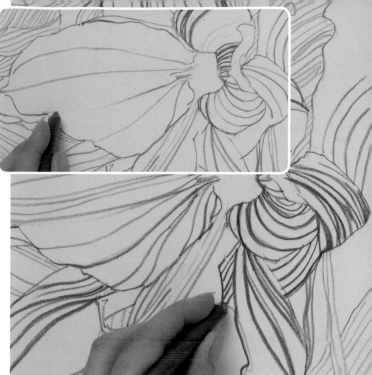

9 Use the emerald green crayon to color the leaves. Draw each line guided by the rhythm and form of the adjacent line; this gives the drawing a momentum of its own, inspired but not enslaved by the natural shape.

10 Use the cadmium red crayon to start filling in the flower outlined with olive green. Apply heavier pressure on the crayon to pull the flower forward; note how the lines provide both the color and the tonal qualities.

11 Intersperse the cadmium red lines with lime green and use olive green to add richness and density to the darker center of the flower. Work hard to inject more detail into this foreground flower; this makes it appear more prominent in the drawing.

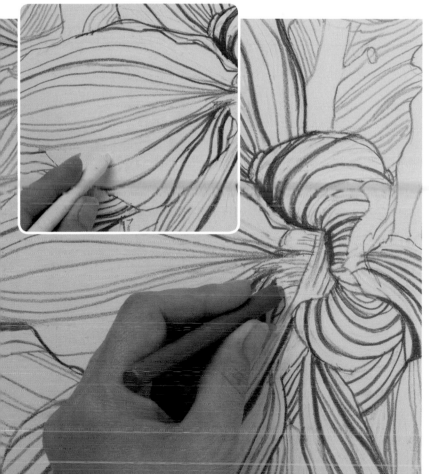

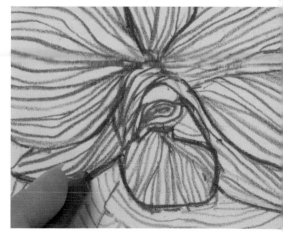

12 Strengthen the lines of the magenta flower to match the intensity of the red and lime green flower – both the flowers will then appear to sit in the same, foremost plane of the drawing.

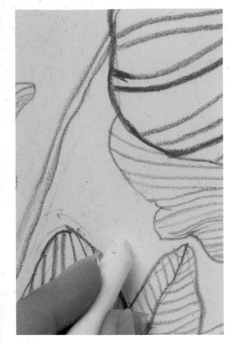

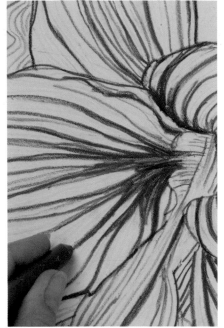

13 Establish the more distant undergrowth with the light powder green crayon. Fill all areas in the drawing – except the sky – with this color.

14 Complete the foreground flowers, boosting their color as necessary in relation to the background foliage. Use a sharpened crayon for finer detail.

15 Using sea blue, make parallel horizontal lines to indicate the distant sea. Draw the lines darker and more closely spaced toward the foreground.

16 Use a wetted medium sable brush to release color from the crayon marks. Work only on the red and magenta flowers that occupy the foreground. The color release intensifies and adds complexity to their forms.

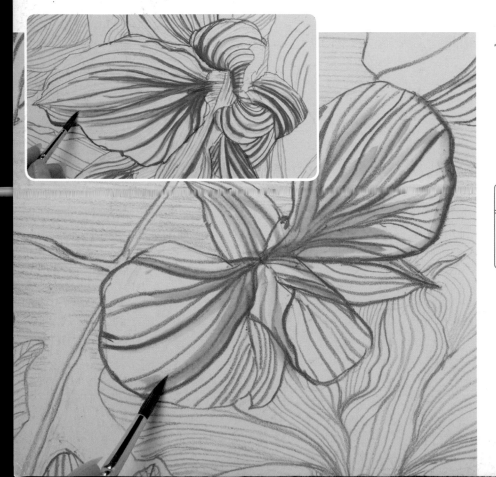

COLOR RELEASE

Release color from one area at a time, and be sure to clean and rewet your brush before moving on to the next area.

▶ Tropical scene

Line alone provides the color and tone in this drawing, and the juxtaposition of line forms – curved versus straight, horizontal against vertical – separates the forms from one another and gives the drawing tremendous energy.

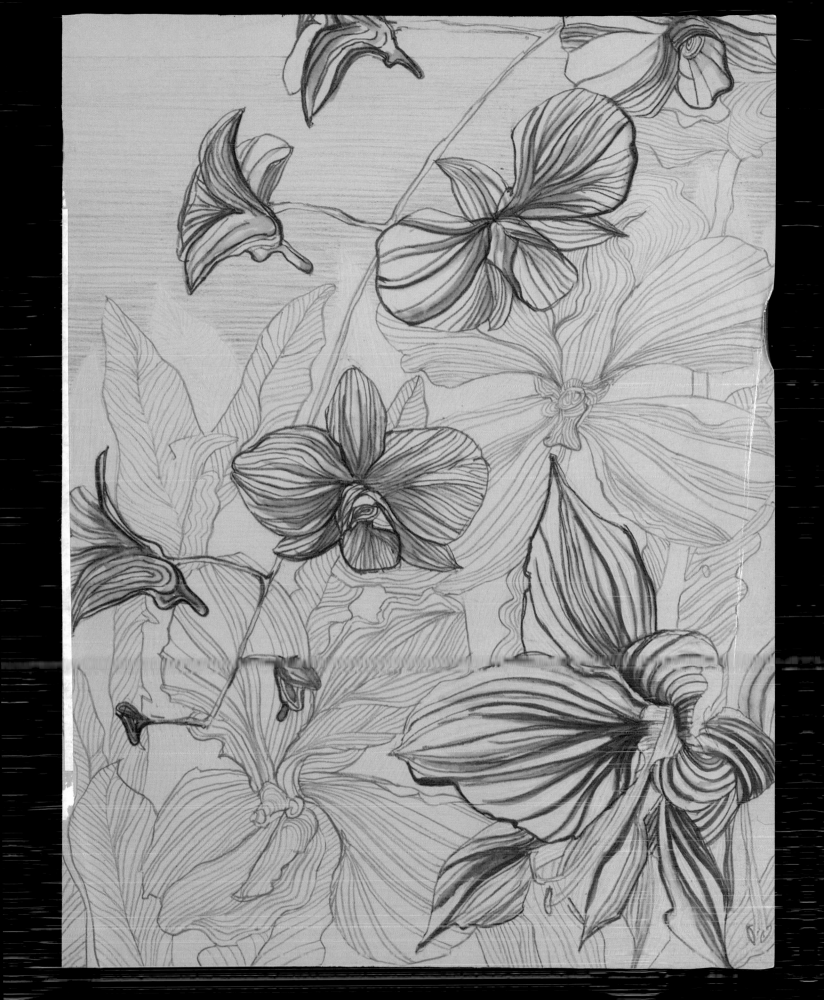

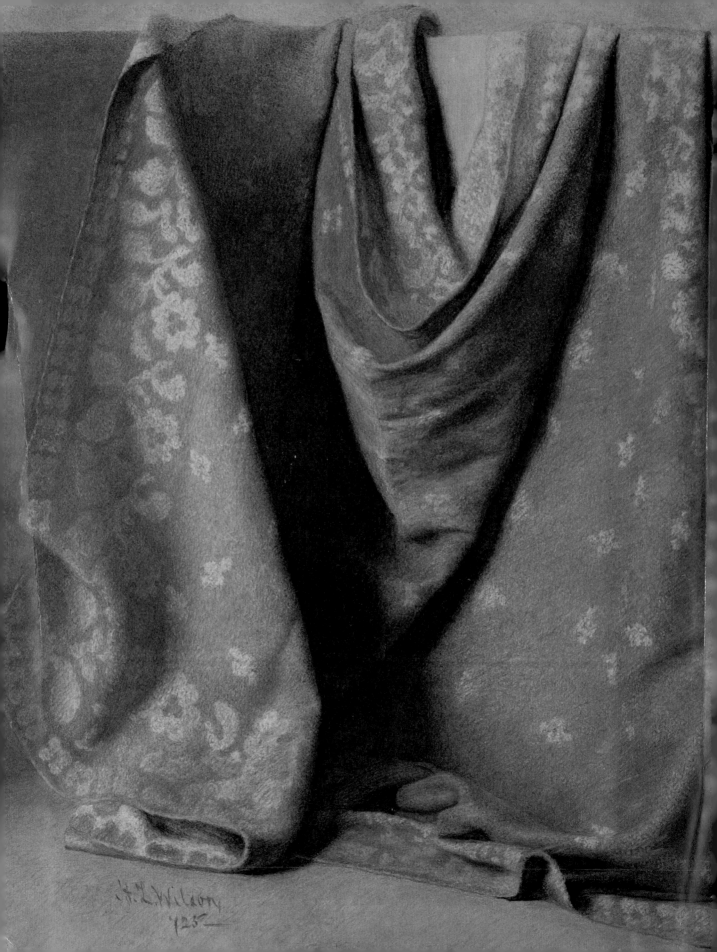

Objects

"Still life remains one of the principal genres of Western art."

Light and matter

The ultimate subject of most drawings is light. Its color, direction, and intensity shape the way that forms appear and contribute to the atmosphere of a drawing. Some artists favor the subtlety of natural light – Giorgio Morandi, one of the finest still life artists of the 20th century, worked only at certain times of day – while others make use of the drama and consistency of artificial light.

LIGHTING THE SUBJECT

It pays to think as carefully about how you light your subject as the nature of the subject itself. Experiment with light from different angles, making sketches that show the effects on form and shadow. Choose a medium that is suited to the light quality and the surface of the object – charcoal is good for soft, diffuse light, pencil for translucency, and ink for dark shadow.

Flat lighting produces no shadows; the colored background provides form by pushing the figure forward.

Natural side lighting produces subtle shadows and a pleasing three-dimensional quality; the blue color contributes to the solidity of the form.

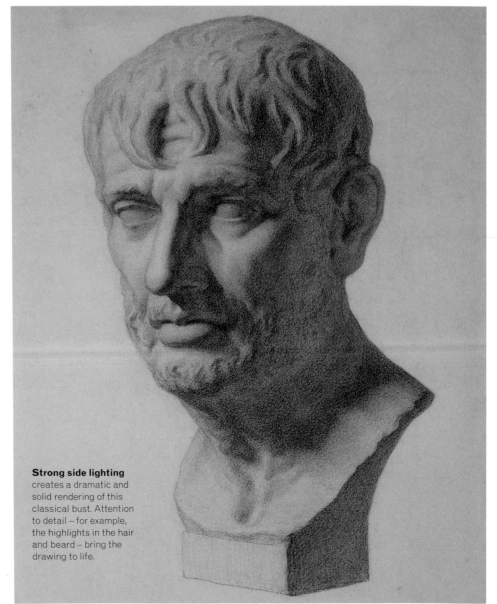

Strong side lighting creates a dramatic and solid rendering of this classical bust. Attention to detail – for example, the highlights in the hair and beard – bring the drawing to life.

SHADOW AND TONE

There's no rule to state that you must draw an object's shadow – if it is omitted, the result is a flat, graphic description. But the shadow cast by an object will help create a sense of context, framing its edges and grounding it within the surroundings. Shadows also set out new areas of space within the drawing – for example, the area beneath a table or an armchair.

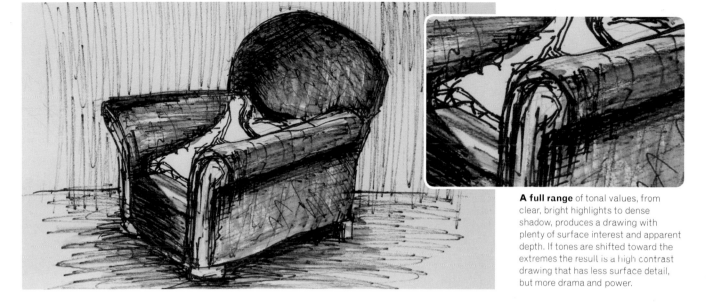

A full range of tonal values, from clear, bright highlights to dense shadow, produces a drawing with plenty of surface interest and apparent depth. If tones are shifted toward the extremes the result is a high contrast drawing that has less surface detail, but more drama and power.

REFLECTION AND TRANSLUCENCY

Glass and metallic objects – especially those with curved surfaces – have complex interactions with light and their surroundings. Space becomes distorted, so don't trust your assumptions; concentrate and closely examine the subject. Always begin with an accurate outline of the form – you need to be sure that proportions and outlines are all correct before shading.

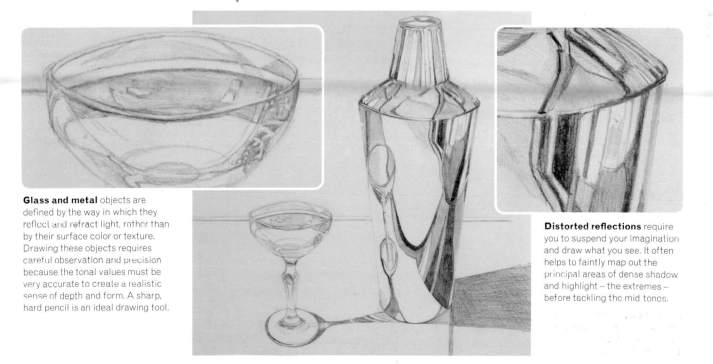

Glass and metal objects are defined by the way in which they reflect and refract light, rather than by their surface color or texture. Drawing these objects requires careful observation and precision because the tonal values must be very accurate to create a realistic sense of depth and form. A sharp, hard pencil is an ideal drawing tool.

Distorted reflections require you to suspend your imagination and draw what you see. It often helps to faintly map out the principal areas of dense shadow and highlight – the extremes – before tackling the mid tones.

Space, media, and expression

The way you place an object within its surroundings will shape the meaning of a drawing. You can choose to isolate the object from its environment, focusing attention on its form and surface qualities, or locate it within a scene that invites the viewer to explore. The media, and the quality of the marks, also set the pitch of a drawing – whether it informs, moves, or challenges the viewer on an intellectual level.

DIFFERENT MEDIA

Every medium has its own qualities – for example, colored pencil makes delicate marks, while ink and brush creates fluid, gestural lines. Clarify your intentions before deciding upon your media – do you want to make a drawing that is analytical, emotional, allusive, or descriptive? However, trust your intuition; there's nothing to stop you making an emotionally-charged image in pen and ink.

MEDIA FOR ANALYSIS AND EMOTION

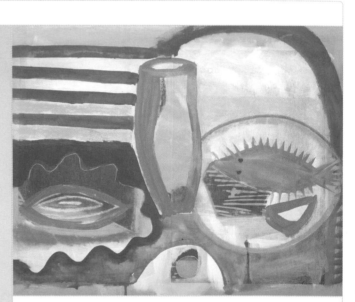

Mixed media – a combination of ink, gesso, and pastel – create an expressive, colorful, gestural drawing that deliberately plays with space and depth to emphasize a sense of exuberance.

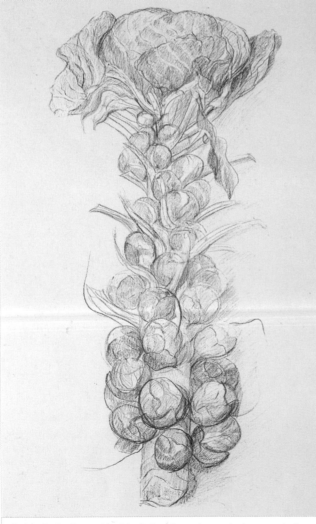

Colored pencil – used for this study of Brussels sprouts drawn centrally on toned paper – allows for fine detail and a degree of decorative expression in both line and tonal work.

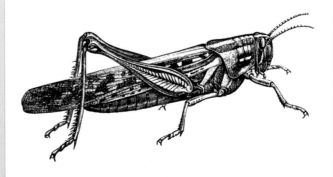

Pen and ink is well suited to this detailed study of a grasshopper. Fine lines capture the intricacy of surface detail, while empty space around the insect focuses attention on the bold rendering of the central form.

GESTURAL DRAWING

There are many ways to translate the observed on to paper without being representative. Gestural drawing does not set out to create a facsimile of the object, but tries instead to suggest its essential feeling; it is concerned with the process of drawing itself as much as the subject depicted. Perhaps the best analogy is to visualize describing the object with your hands as you talk – your gestures are akin to those you make when gesture drawing.

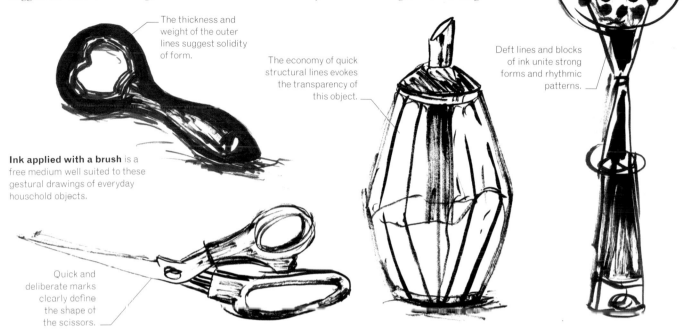

The thickness and weight of the outer lines suggest solidity of form.

The economy of quick structural lines evokes the transparency of this object.

Deft lines and blocks of ink unite strong forms and rhythmic patterns.

Ink applied with a brush is a free medium well suited to these gestural drawings of everyday household objects.

Quick and deliberate marks clearly define the shape of the scissors.

RELATIONSHIPS BETWEEN OBJECTS

When preparing to work with a group of still-life objects you should experiment with different arrangements. The relationships between forms are defined both by the placement of objects and the negative space between them; these factors will influence the emotional pitch of the drawing. Compare the two drawings below: in the first, your eye is led backward through the spaces between the stones; in the second, it gravitates toward the central structure.

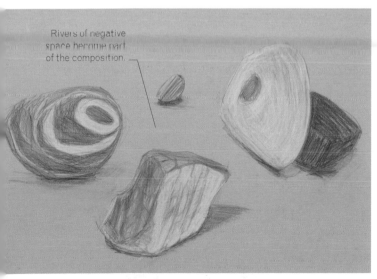

Rivers of negative space become part of the composition.

This drawing in colored pencil possesses a real sense of depth; rhythmic placement of the objects and a colored ground create an open environment that the eye can explore.

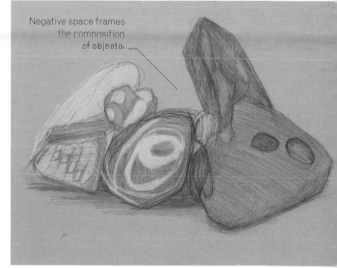

Negative space frames the composition of objects.

With the objects closely linked in a block form at the center of the drawing, the eye is confined to their surfaces and does not explore beyond the objects. The result is a solid, monumental composition.

Still life remains a compelling and timeless subject for drawing because it allows for both intimate and analytical explorations of form.

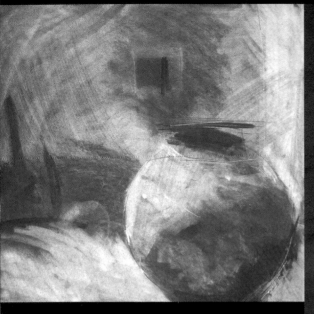

▲ Mediterranean courtyard

A large urn sits firmly in the foreground, appearing almost to fall out of the drawing, which is preoccupied with expressing light and tone. The soft yet dynamic surface quality is created using charcoal and an eraser. *Andrew Gibbs*

▼ Apples and cherries

This carefully considered view of fruit is immediately intriguing; we sense we are looking down on to the still life as if standing at the kitchen table. The reflective and peaceful quality of the image is achieved by delicate line work combined with smooth application of tone. *Unknown*

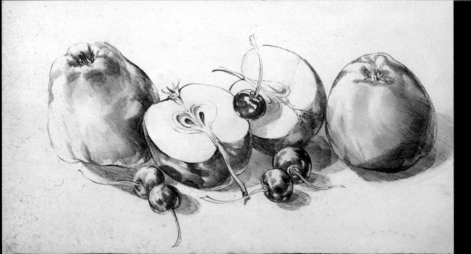

▲ Still life study of urn

Intense and highly worked passages of sepia pastel have been built up with great precision to create a dramatically staged still life. Tiny windows of reflected light, which sparkle in the darkness, add further theatricality to this scene. *JR Barnett, Norwich School of Art and Design Drawing Archive*

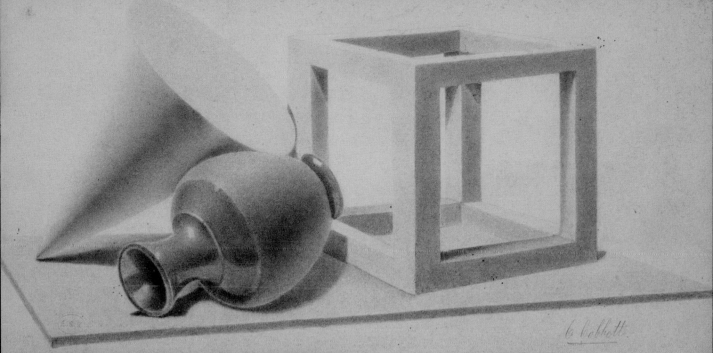

▲ Grouped forms

Classical studies of grouped objects explore the effects
of light on form, and heighten skills of analysis and
draftsmanship. This soft, blended pencil study creates a
tangible sense of solidity in the objects; with white objects
against a white background, the subtlest tonal work holds
the forms of the objects. *C. Cobbett, Norwich School of Art
and Design Drawing Archive*

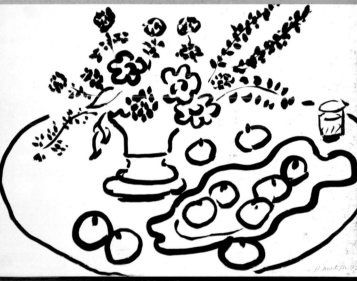

▲ Still Life with Flowers

Matisse was a master at creating deft yet spontaneous drawings.
He is playful with his mark making, forcing the formal elements
of his composition to take on animated characteristics and
literally jump for joy. *Henri Matisse*

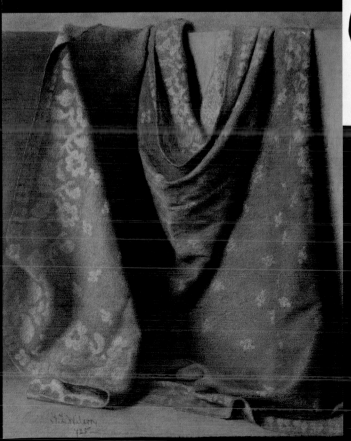

◀ Draped cloth

This sumptuous drawing made on a fibrous paper meticulously
explores the pattern and surface textures of a draped blanket. It
conveys a great sense of depth through the intense black shading
and tonal work in the creases between the folds. *H. L. Wilson,
Norwich School of Art and Design Drawing Archive*

4 The red shoes

Combining different media is exciting because there's every chance that you'll produce a drawing that is far more than the sum of its parts. In this project, grayscale tone in pencil and graphite is mixed with colorscale tone in red chalk pastel. The result is a surface rich in texture and color that is ideally matched to the subject – a pair of red suede shoes made up of curved, fluid forms. Working successfully in mixed media requires constant reassessment – adding one element may demand counterbalancing with the other, and vice versa.

EQUIPMENT

- Heavyweight off-white watercolor paper; choose a thick resilient paper that can withstand the application of heavy lines and aggressive rubbing out
- 2B, 4B, and 5B pencils
- 2B and 6B graphite sticks
- Plastic eraser
- Cadmium red, Windsor red, and fuschia deep chalk pastel sticks
- Cadmium red pastel pencil

TECHNIQUES

- Blending pastel
- Mixing media

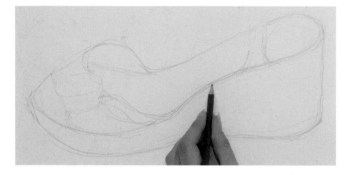

1 Make a series of lines with the 2B pencil, keeping your eyes on the shoes, not the paper. Hold the pencil loosely, and attempt to "find" the ouline of the shoe. Try not to be too analytical at this stage – think of this process as touching the object rather than examining it.

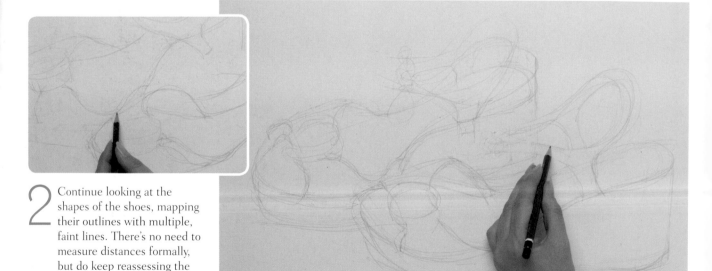

2 Continue looking at the shapes of the shoes, mapping their outlines with multiple, faint lines. There's no need to measure distances formally, but do keep reassessing the spatial relationships between the shoes.

BUILDING THE IMAGE

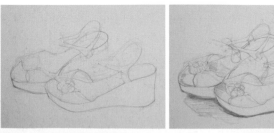
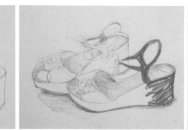
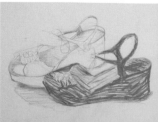

3 Draw the looped forms of the laces and decorative flowers, and then pick out and strengthen the lines that carry the form of the shoes with the softer 4B pencil. Rub back your faint working lines with the plastic eraser. Rest your hand on a sheet of paper to avoid smudging the existing lines.

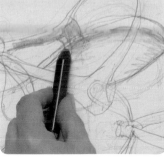

4 Begin adding gray tone with the graphite sticks – use the 2B stick for the finer, more detailed areas, and the softer 6B for the broader areas. Think in terms of distinct areas of tonal value and faintly draw the contours of the different tones before shading.

5 Shade lightly at first, then build up the darker tones. Apply heavier shadow beneath the shoes; change the direction of the shading, using both hatching and curved directional marks for interest.

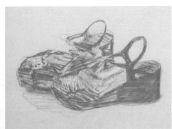

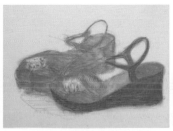

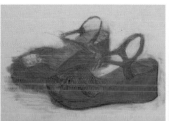

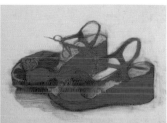

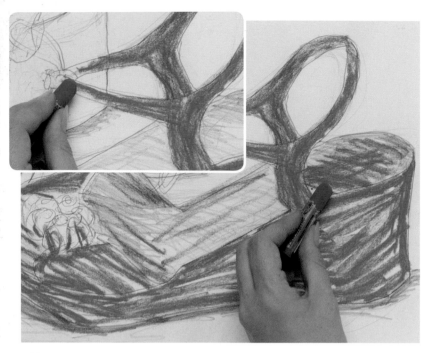

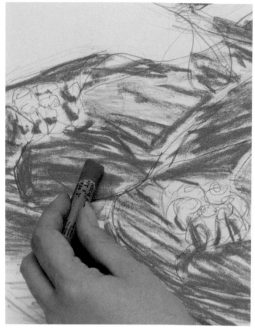

6 Color one shoe at a time using the cadmium red pastel stick. Move across the shoe from left to right (or right to left if you are left-handed) to prevent unwanted smudging. Keep the crayon marks loose; the tone will be established later by blending with your fingertips. Blow excess pastel powder away from the drawing (blowing from above the red shoe): the powder marks the paper, producing a faint red glow around the shoes.

7 Roughly build up the correct densities of color. Don't worry if you go over the pencil boundary line: energy is more important than neatness in this drawing.

SMUDGING PASTEL

Some makes of pastel are chalky; others sticky. The former are better for smudging, so find the one that's best suited to your style.

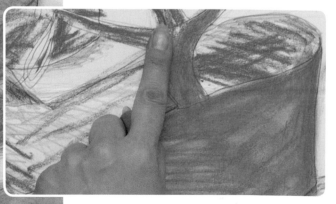

8 Smudge the red crayon with your index finger. Spread the pastel just a little at first so that you can evaluate the placement and quality of the color. Follow the shapes of the shoes as you smudge, using your finger as a drawing implement. Be sure to blend the pastel into the paper – you need to press it in well because the pastel will be drawn over later with graphite, so should not be too loose.

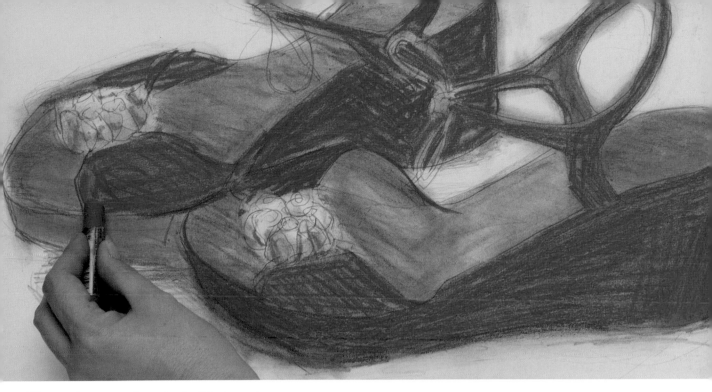

9 Use the stronger hue of red – Windsor red – to work over the blended pastel in selected areas. Build up layers of pastel to match the intense, deep red color of the nap of the suede. The cadmium red acts as an undercoat for the Windsor red, eliminating any whiter areas and making the color glow.

"Familiar objects, invested with personality, make great subjects."

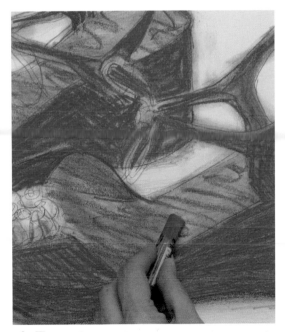

10 Working roughly, apply Windsor red over the tone on the inside of the shoe. The drawing process is like a seesaw, because it involves adding tone and color, then taking it away, always responding to what emerges.

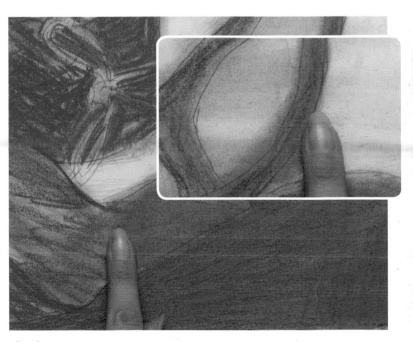

11 Start rubbing back the color with your index finger; allow yourself to smudge a little beyond the shoes' edges because this helps to frame them and gives them dimensionality. Keep a little unevenness, rather than making the pastel completely smooth, to hint at the roughness of the suede fabric.

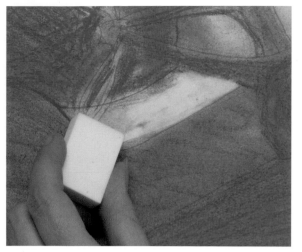

12 Using the plastic eraser, take away excess shading from around the shoes and rub back the clear areas between the straps. Leave some red marks in the highlights so they retain tonal interest.

13 Return to the line components of the drawing, which have been obscured by the application and blending of color. Reinforce these outlines with the 6B graphite stick to bring them forward.

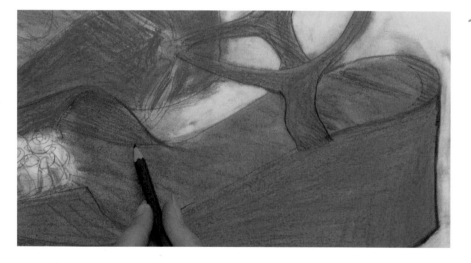

14 Work across the whole drawing from left to right, adding to the grayscale tone using the 6B graphite stick for broader areas, and the 5B pencil for finer tonal details. Closely analyze the gray tonal values compared with the red and adjust as necessary; pause every few minutes and be self-critical – the balance between the media is crucial to the success of this piece.

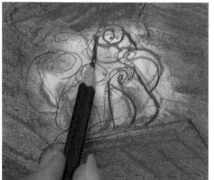

15 Pick out the line details of the decorative flowers on the shoes using the 5B pencil. Work expressively but attentively, and make sure to sharpen the pencil regularly.

16 Use the sharp cadmium red pencil to color the floral details in the shoes. Draw the detail accurately and finely to bring the flowers forward in the drawing.

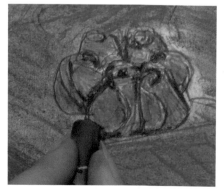

17 Use the fuschia deep pastel stick to add stronger color to the margins of the flowers; this lifts them above the tone and texture of the shoes. Ensure that all areas of white are covered.

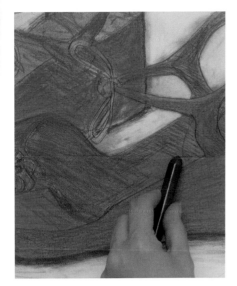

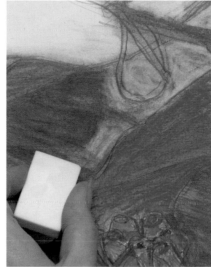

18 Continue adding tone to the insole using the 6B graphite stick. Notice that gray tone is placed both below and over the red – it is this that gives the surface its solidity of form.

19 Lift tone to create highlights using the plastic eraser. Work with the eraser in a slightly different way, sliding it across the surface to blend and soften the lines.

20 Apply more Windsor red to the front parts of the shoe and the laces. Return with the eraser to rub back excess line, tone, and color, and smudge the surface to give an even finish.

▼ The red shoes

A balanced relationship between the pastel and graphite marks has produced a dynamic still life. Traces of the working processes – smudges beyond the objects – inject an element of urgency into the finished drawing.

5 Flowers in a vase

This study mixes pastel drawing with collage techniques and an application of gesso to create a textured, faintly colored ground that accentuates the vibrant, organic nature of the subject. Energetic, rather than formally analytical, the method used invites you to engage directly with the subject – a bunch of exotic flowers in a bottle-green vase, simply lit with one spotlight. Fluidity of movement and boldness when using the pastels are key to a dynamic drawing; try working accompanied by your favorite music – it helps you stay relaxed.

EQUIPMENT

- Heavy white watercolor paper
- Collage papers and paper adhesive
- Acrylic gesso and decorator's brush
- Chrome green vibrant, Madder Lake deep, cadmium orange, lemon yellow, Prussian blue, lent green, turquoise blue, chrome green deep, dark olive, white, gray-green, dark gray, and Windsor red chalk pastels

TECHNIQUES

- Using gesso
- Using collage paper
- Blending pastels

SETTING OUT THE COLLAGE

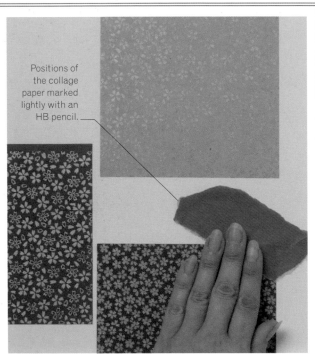

Positions of the collage paper marked lightly with an HB pencil.

Lay down the collage papers on the watercolor base sheet: wrapping paper, origami paper, and even old envelopes are suitable. Roughly match the composition of the collage with the position and color of elements in the subject.

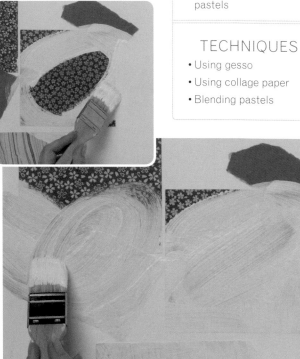

1 Glue the collage papers firmly to the base sheet with the paper adhesive, using your pencil marks as guides. Use a decorator's brush to coat the entire surface of the paper with gesso, working it to mirror the forms of the flowers – the brushmarks persist and add texture to the finished drawing.

BUILDING THE IMAGE

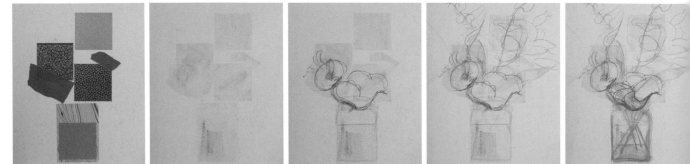

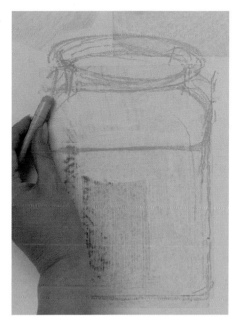

3 Map out the shapes of all the richly colored flowers. Use the Madder Lake deep pastel to outline the large red lily, the cadmium orange pastel for the gerberas, the lemon yellow pastel for the yellow lilies, and the Prussian blue pastel to trace the outline of the white lilies.

2 Allow the gesso to dry for 3–4 hours. The form of the collage papers will be faintly visible beneath. Begin drawing with the chrome green vibrant pastel to establish the shape of the glass vase; mark in the water line and the lip of the vase.

GESSO

A mixture of chalk and acrylic polymer, gesso is used to "prime" surfaces so they hold pigment. It provides a flexible, white drawing surface.

Ridges in the gesso hold the pastel pigment.

4 Start drawing the foliage with the leaf green pastel. Note how the pastel picks up the irregular texture of the gesso to suggest a leafy surface. Rub back the green pastel with a fingertip, then apply more pastel to build up areas of color.

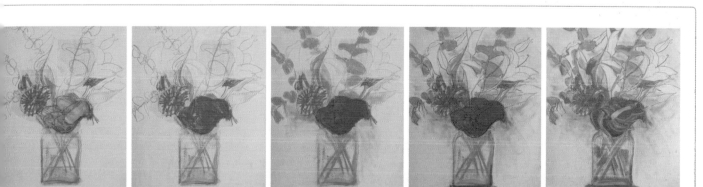

5 Use the chrome green vibrant, lent green, and turquoise blue pastels to depict the water and submerged leaves. Smudge and blend with your fingertips to create an impression of watery translucency; build the intensity of pastel from the bottom of the vase to imply depth.

6 Use darker green pastels – the chrome green deep and dark olive – to add depth to the foliage. Don't hold the pastel too rigidly like a pencil, and try consciously to "walk" up the stems, rolling, pushing, and pulling the pastel following the natural curves of the leaves.

7 Begin building up tone in the flowers within the principal oulines that you have set out. Use the Madder Lake deep pastel to shade in the large red lily; mark out the position of its spadix (the long flower-bearing structure at the center of the red petal-like spathe). Rub the pastel back with your finger to blend together the tones.

8 Repeat the previous step using cadmium orange to color the gerbera. Work heavily with the pastel to boost intensity rather than being overly concerned with line detail, which will come later. This is where the quality of your materials really shows: using chalk pastels that are soft and rich in pigment enhances the vibrancy of the drawing.

9 Return to the large red lily and lay down a heavier layer of the Madder Lake deep pastel over the existing line and tone, blending with your fingertips. Building tone in layers in this way adds richness and complexity to brightly colored foreground objects.

10 Work within the blue outlines of the white lilies with the white pastel. Using the pastel, drag some of the blue color into the white petals, following the form of the veins of the flowers; this provides surface interest in the pure white lilies.

"Rubbing back and selectively rebuilding layers of pastel creates atmosphere."

11 Use the gray-green pastel to color the ash green leaves. Create a surface behind the leaves, and soften the harsh white of the paper, by using your fingertip to drag some color across the leaf outlines into the background.

12 Vigorously drag pigment from the vase and stems outward into the background area using several fingers. Dragging pastel across the edges of the collage paper emphasizes the form of the underlying collage, which then contributes to the composition.

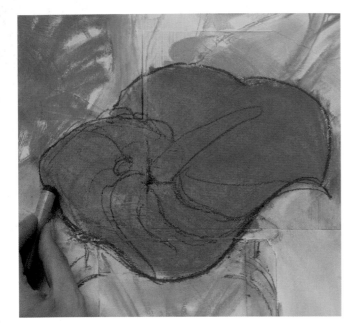

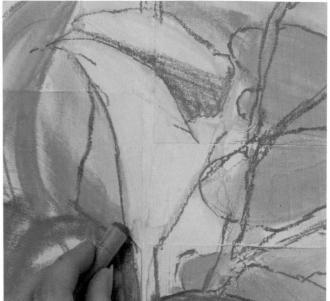

13 Re-examine the form of the red lily, looking closely at where shadows fall on the flower. Use the dark gray pastel to add this detail – work with the edge of the pastel to produce a finer, more controllable line.

14 Use the dark olive pastel to re-establish the outlines, contours, and shadows of the yellow, orange, and white flowers. This helps to throw the flowers in front of the softer blended pastel background.

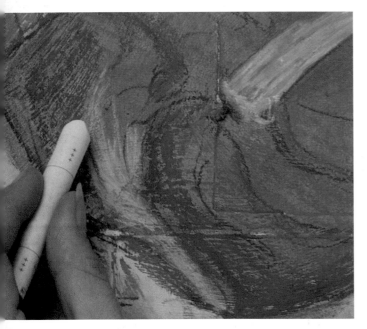

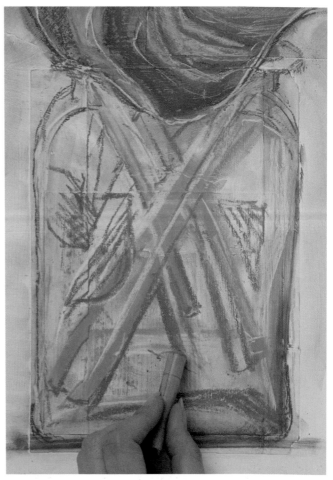

15 Add richness to the red lily with the Windsor red pastel, and use the cadmium orange pastel to color the spadix. Use the white pastel for highlights: these bring the lily to life as they catch the ridges on the waxy spathe.

16 Blend the highlights following the organic forms of the flower. Use the dark gray and white pastels to refine the shadow and highlight areas on the submerged stems. Blend and smudge to add realistic relief.

▶ Flowers in a vase

In the finished drawing, the edges
of the collage paper are still
visible, giving an extra textural
dimension – a layered effect that
suggests different planes of the
leaves and flowers. Starting with
the collage is an interesting
exercise because it gives you
something to react to, other than
just the subject, and so injects a
new, arguably more personal,
element into your drawing.

6 Jars and jugs

Crosshatching is a sensitive way of defining tone and three-dimensional form in pen and ink drawings. The technique allows you to create tone by varying the frequency of line – the closer together the lines, the darker the impression. Crosshatching is used not just in drawing but also in etching and engraving – traditional techniques where the lines can be even more delicate. This project captures some of the qualities of old engraving, using sepia pens – softer and more appealing than harsh black on white – to render a classic still life composition made up of bottles, jugs, and jars.

EQUIPMENT

- Warm yellow thick drawing paper
- 2H pencil
- Waterproof fiber-tip sepia ink pens: B (broad); M (medium); F (fine); and S (superfine)

TECHNIQUES

- Crosshatching to express tone, form, and shadow
- Capturing highlights and shadows

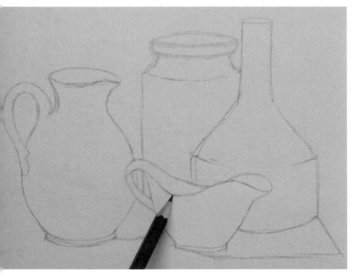

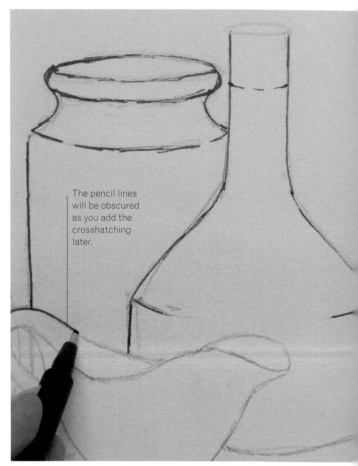

The pencil lines will be obscured as you add the crosshatching later.

1 Use the 2H pencil to lightly mark out the shapes and relative positions of the objects and the key shadows that ground them. Measure the dimensions as necessary (see p. 22) as you map out the composition – it is important to get this right now as your later ink marks will be hard to correct.

2 Work over the pencil outline with the B ink pen. Try to be loose with the line, varying its strength and width; this helps give the objects character from the outset. Break the flow of the line in places to add further interest to the drawing.

BUILDING THE IMAGE

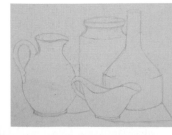
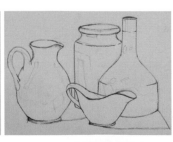
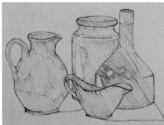
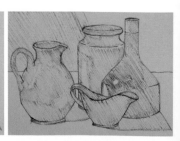

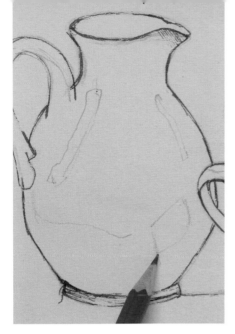

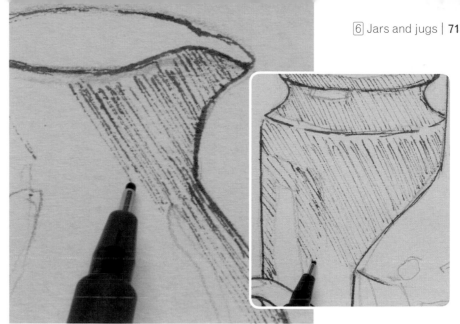

3 Using the 2H pencil, map out the areas where reflective highlights fall; when you start shading with the crosshatch technique, you'll need to work fast.

4 Start adding tone, using the M ink pen. Work on one object at a time – you should aim to maintain the continuity of each line. Make penstrokes in one direction only, and keep the frequency of lines more or less even, so you are not yet suggesting large differences in tone.

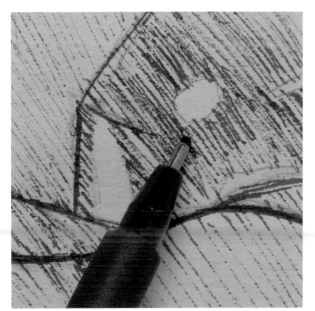

"Think about this drawing as a map of different tonal areas."

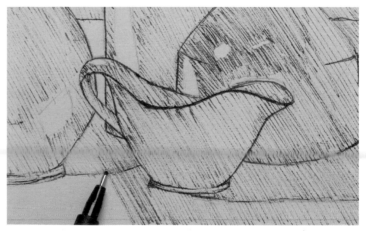

5 Work boldly to inject energy into the drawing. Lines that spill over the edges of an object are not a problem – the background will be shaded later.

6 Draw a horizontal line to indicate the back edge of the table. Shade the background, making lines in the same direction as those used for the objects; keep the tonal density even.

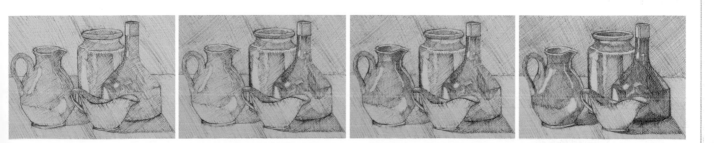

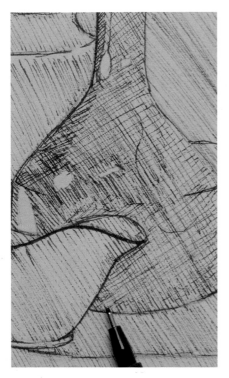

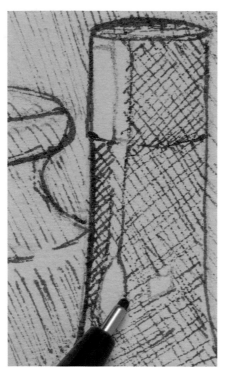

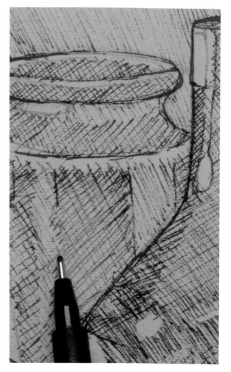

7 Begin making lines at right angles to the existing shading, still using the M pen. Vary the frequency of the lines to establish areas of different tone, which helps to create the illusion of form.

8 Continue crosshatching, working on one object at a time. When you arrive at a delineated highlight area, start your penstroke on the edge of the highlight and work away from it, to keep the area bright.

9 Keep evaluating the tonal densities of the objects as you go. Ensure that you are making creative decisions all the time; don't be tempted to think that you are merely "filling in" the crosshatching.

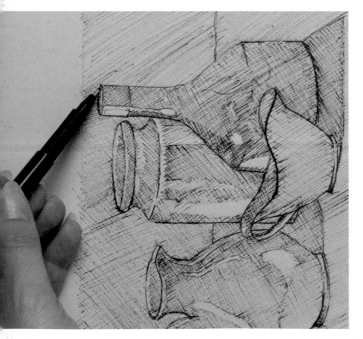

CONTROLLING DENSITY

When crosshatching, you can create denser tone by increasing line frequency, adding more layers of lines, by pressing harder, or by using a thicker point to your pen.

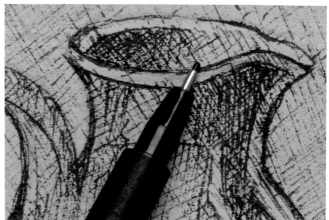

10 Build density in the darker areas of the subject by adding further passes of crosshatching at different angles. Turn the paper on its side so that you can make marks with natural, flowing movements of your hand.

11 Now switch to the F pen. Begin reinforcing and bringing out the lines within the drawing, and add more fine crosshatching to the shadow areas: at this point the drawing should gain real depth.

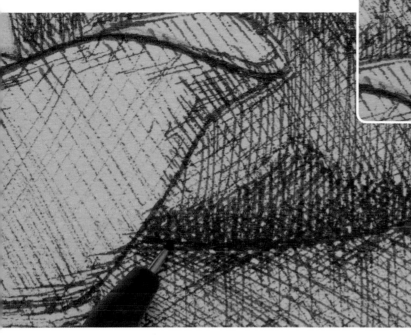

12 Continue refining tone and building line with the finest S pen. Allow the crosshatching to spill over at the bases of the objects into areas where the shadow is intense – this helps to ground the objects on the surface.

▼ Jars and jugs

Crosshatching lends itself perfectly to this still life composition, where surface and reflection are the true subjects of the drawing. Very subtle differences in tone are achieved by varying the frequency and strength of the lines.

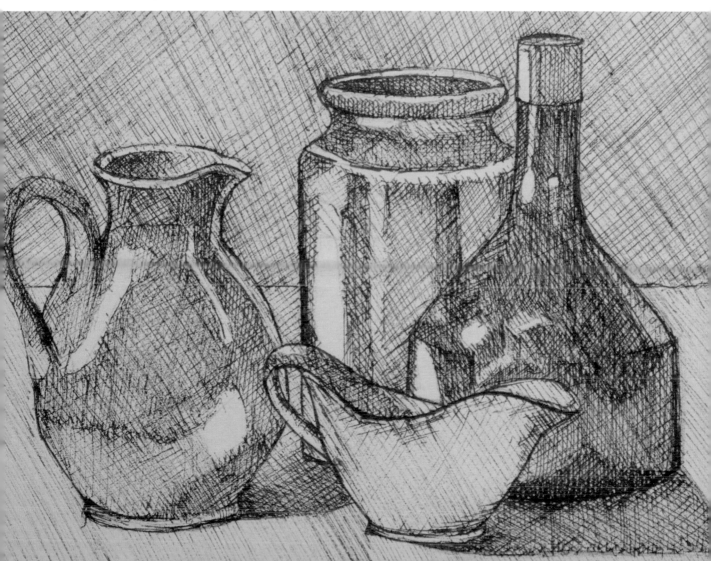

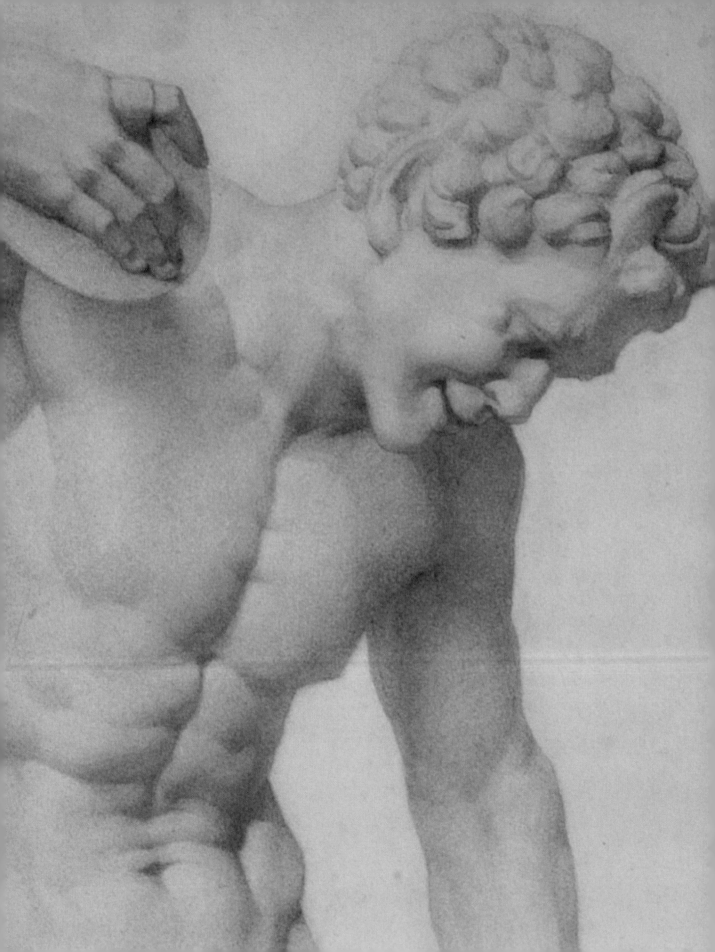

"The human form offers an endless source of inspiration for its beauty and its character."

The classical nude

Figure drawing has been the gold standard of artistic skills since the ancient Greeks set out the blueprints for depicting the body, based on their ideals of physical perfection. The figure remains a wonderful challenge. It presents technical difficulties – foreshortening, depicting life, individuality, and dimension – as well as the opportunity to explore the human condition, from the heroic to the humble.

DRAWING FROM LIFE

To fully meet the challenge of figure drawing, you should work from life, but much can still be learned by drawing from museum statues or even photographs. Classical poses typically exaggerate the curves and balance of the body; they may include a twist from the waist that creates a gentle dynamic within the form and therefore a more interesting pose.

POSES AND PAPERS

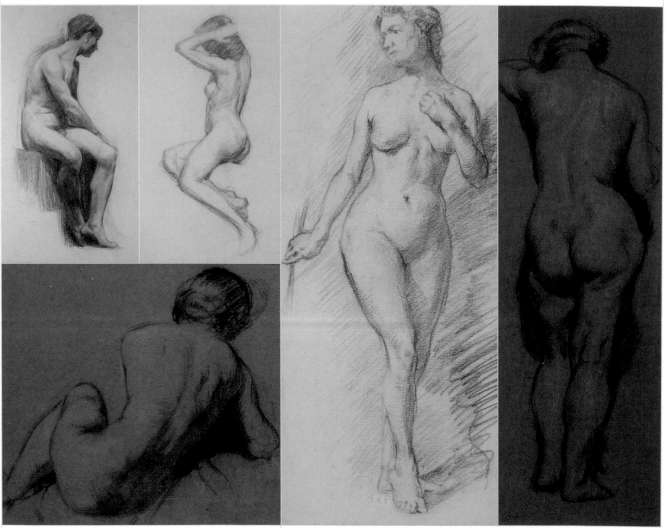

Using a colored ground allows you to use the paper as the base color for the skin, and then to add light as well as dark tone to build and accentuate the forms.

Standing poses make a strong – almost monumental – vertical statement, while reclining poses tend to create more interesting negative spaces between the limbs and torso.

ANATOMY AND FORM

An understanding of the body's structure is essential if you are to give full expression to its spirit. Studying anatomy in books and sketching models informs you about the construction of the body, its proportions, and how the muscles, tendons, and skeleton direct and control the body. There is no need to memorize the position of every muscle and bone, but you should be familiar with key physical landmarks that will assist your work – the vocabulary of life drawing.

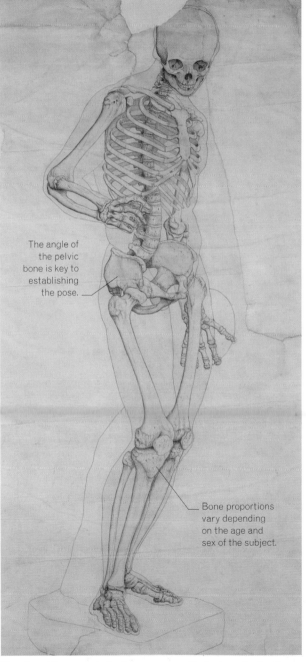

The angle of the pelvic bone is key to establishing the pose.

Bone proportions vary depending on the age and sex of the subject.

Muscle and bone create the forms we see on the body; understanding their structure allows us to see where tension is created.

The muscles of the scalp are so thin that the outline of the bone is visible beneath.

The external obliques are the only abdominal muscles to have much influence on surface form.

Muscles soften the human form and provide the key contours of the body.

The fleshy mass of the calf is produced by two separate muscles.

Feet and hands possess an inherent energy and expressiveness.

The human form in focus

Facial features, hair, hands, and feet are common stumbling blocks for artists because they are highly complex in form and surface, and need concentrated observation matched by technical aptitude. Mistakes in representing form and proportion glare out from the paper, because we are all so familiar with the human body. There is no easy formula for success: advance your skills through constant practice.

HEAD AND FACE DETAIL

The head is basically an oval shape, symmetrical around its vertical axis. This seems obvious, but is worth remembering when drawing three-quarters views of the face. A horizontal line drawn through the eyes defines the middle of the face – humans have very high foreheads. Though much of the forehead may be covered by hair, the forehead still extends forward above the eyebrows.

REPRESENTING HAIR

Layered, broad brush strokes evoke the weight and curvature of the hair.

Bold, energetic charcoal lines define the structure of the hair and frame the face.

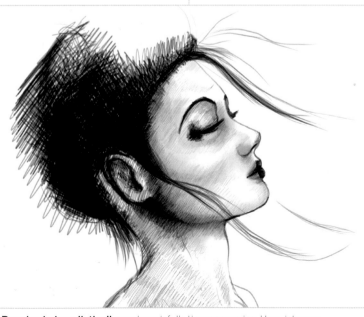

Drawing hair realistically can be painfully time-consuming. Here, ink cross-hatching captures the overall tonal qualities of hair, while a few fine lines describe individual strands, giving an impression of great detail throughout.

EYES IN LINE AND TONE

Fine, precise line perfectly describes the shape of the eye. Simplicity and accuracy are capable of conveying gaze just as well as detailed tonal work.

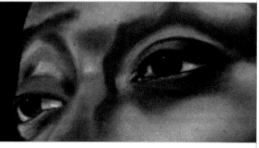

Diffuse pastel work captures the form of the eye. In nature, the whites of the eyes are never pure white and reflections show a curved surface.

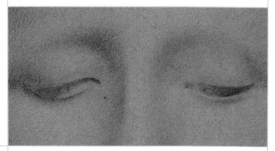

Delicate pencil work, carefully observed, perfectly captures the gentle downward gesture of the model's gaze.

BODY DETAIL

Hands and feet, fingers and toes pack a lot of structural complexity into a small area. For this reason you'll see many drawings – even by old masters – where they have been deliberately omitted. There's no need to be intimidated, but a basic knowledge of anatomy is vital in supporting your drawing skills. It helps to draw each part of a finger or toe as a short cylinder, with an oval overlapping the next to form the joint; from here, subtle variations of shape can be built up.

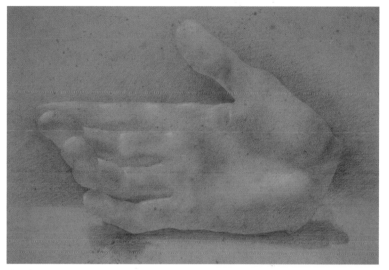

Hands are expressive and may indicate aspects of character and narrative. Study and sketch the hand at rest and in tension to hone your skills.

Detail is key in bringing life to representational drawings of the human form. In this charcoal drawing, note the way the artist has paid attention to small undulations and irregularities in the surface, and has suggested muscle groups through subtle tone.

The foot is commonly foreshortened in a drawing and requires accurate observation. Bones, tendons, and veins are very evident, adding further complexity to the form.

The drama of the body

When you become confident in observing and drafting the human form, you can move into new creative territories, where the figure becomes a player within a visual narrative. Working on pose and gaze humanizes a model, inviting us to engage with their lives and their thoughts beyond the image. Posture and color can suggest movement, emotion, and intention, placing us firmly within the subject's world.

NARRATIVE AND THE HUMAN FORM

To construct a drawing with a strong sense of narrative, you need to think like a writer. Make notes and sketches relating to characters from your own life, or allow yourself to be inspired by a passage in a novel or a scene from a play. Study theater and movie sets and the gestures and expressions of actors; use color and texture to create atmosphere and contextualize your ideas.

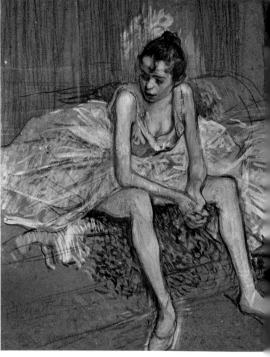

Degas drew intimate studies of dancers in relaxed poses, using vibrant strokes of vivid pastel color to contrast the wistful expressions of his young models with their theatrical environment.

Movement is present in this narrative drawing of a circus juggler. Using charcoal and an eraser in a gestural and energetic manner evokes the frantic energy of the subject.

CREATING MOVEMENT

Depicting motion became a major preoccupation for modernist artists – such as the Italian futurists – because it provided a means of breaking away from classical constraints.

Dynamism can be injected into a drawing by transferring physical energy when making marks. Experiment with different media, making fast abstract lines across the surface.

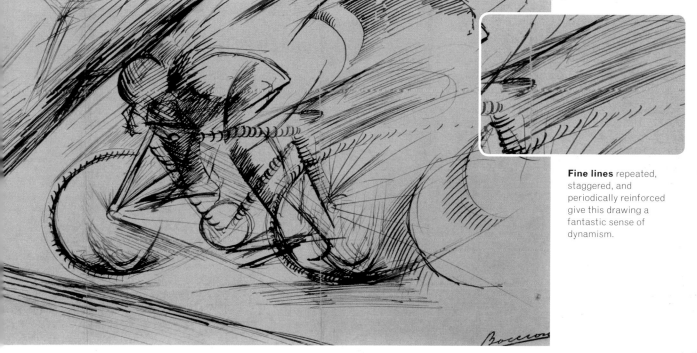

Fine lines repeated, staggered, and periodically reinforced give this drawing a fantastic sense of dynamism.

Vivid color injects motion and urgency into this study for a painting of a jogger moving through an urban landscape. The color appears to vibrate from the forms, which are established using loose brush strokes, spreading movement throughout the entire scene.

Gallery

Approaches to the human form span the analytical, emotional, and dramatic and make use of a huge range of drawing processes.

▶ Reclining nude

A fashion for classical art is reflected in this well-observed pencil sketch. The model poses within an imaginary Roman scene, inviting us to ponder the landscape beyond. *AJ Munnings, Norwich School of Art and Design Drawing Archive*

▼ Classical study

This elegant study in monochrome Conté crayon recalls a Renaissance statue with broken limbs. *Unknown, Norwich School of Art and Design Drawing Archive*

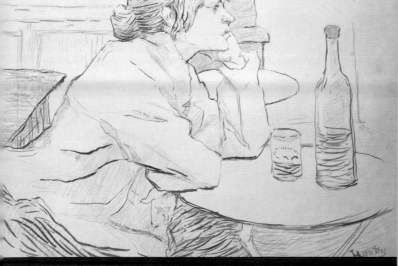

◀ Young Woman Sleeping

Emerging from the ethereal traces of drawn brush marks, the sleeping woman appears as a dreamlike apparition. The proficiency of this drawing is evident through its economy of line that so beautifully conjures up the human form in repose. *Rembrandt*

▼ Discus thrower

A plaster cast of a classical statue provided the lengthy pose needed for this supremely detailed and closely observed pencil drawing. Lines are blended into hazy tone, which creates a smooth but solid surface to the body. *H. L. Wilson, Norwich School of Art and Design Drawing Archive*

▲ Woman Drinker, or The Hangover

In keeping with the subject matter, this ink and colored pencil image appears raw and roughly made, yet close examination reveals great attention to detail and sensitivity in mark making that perfectly captures the scene. *Henri Toulouse-Lautrec*

7 Seven for one

Free, gestural drawing is tremendous fun because precision takes a back seat, allowing you to concentrate on sensitivity of touch. In this study, ink applied with a Japanese calligraphy brush is used to create a sensuous drawing of the human form. Making several repetitions of the drawing and using a self-critical eye to identify the strengths and weaknesses of each produces the best results. You'll need to work on an easel: the brush should contact the paper head-on – almost impossible to achieve comfortably if you are seated.

EQUIPMENT
- Plain white cartridge paper (choose a relatively cheap paper because this project demands several repetitions)
- Japanese calligraphy brush
- Japanese black drawing ink

TECHNIQUES
- Drawing with a brush
- Quick, gestural drawing

POSING THE MODEL

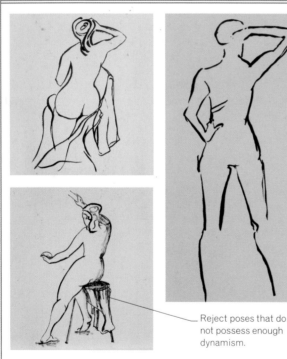

Reject poses that do not possess enough dynamism.

Ask your model to shift weight on to one leg, or to stretch out her arms and hands – anything that creates tension in the pose and defines harmonious areas of negative space. Make quick sketches of possible poses and select one to develop.

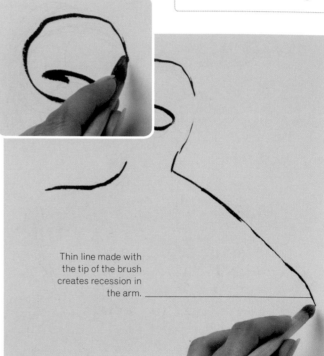

Thin line made with the tip of the brush creates recession in the arm.

1 Look at the model and mentally break down the form into a number of smooth lines, each of which can be made with one continuous movement. Load the brush with ink, and using a light but even weight of line, draw the head. Draw the slope of the shoulder and arm in relation to the head.

BUILDING THE IMAGE

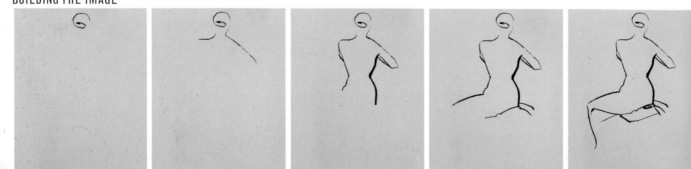

Heavier line brings the hip forward, creating dynamism in the drawing.

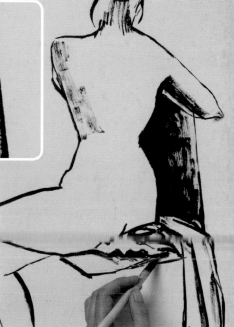

2 Establish the side of the body, pressing harder on the brush to make the line wider. Increase the pressure on the brush as you descend to boost the strength of line in the hip area.

3 Reload the brush with ink, then draw the outline of the draped cloth on the chair in order to "seat" the model. Avoid making fussy marks – purity and clarity of line are key to the success of the drawing.

4 Closely examine the position of the bend of the knee in relation to the base of the chair and the feet before drawing these elements. Add shadow beneath the left knee to establish the position of the leg.

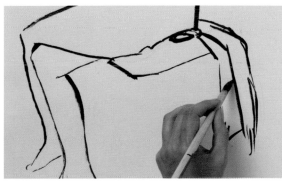

5 Work on the form of the draped cloth, analyzing its folds and their positions relative to the back of the chair. Keep the brush loaded with ink so you can make smooth strokes.

6 Wipe the brush to reduce its ink load and add tone to the model's back. Create an uneven texture by using the side of the brush here and in the hair. Fill the black tone of the chair and the deep shadows under the arm with heavier strokes.

QUICK DRAW

Pencil underdrawing is not needed when working with ink and brush; while it may improve accuracy, it compromises speed and spontaneity.

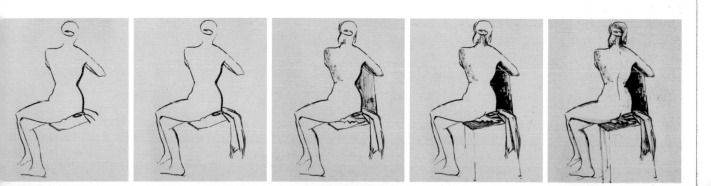

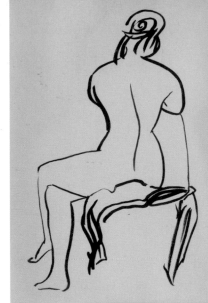

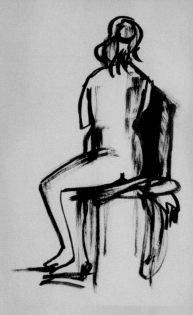

7 Use the tip of the brush to indicate the presence of the chair legs; there's no need to draw them in detail – indeed this would detract from the strong graphic form made by the model's body.

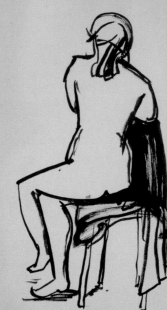

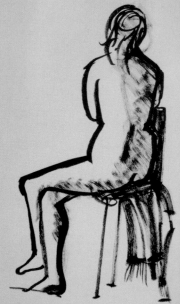

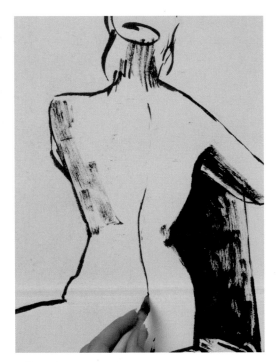

8 Draw the line of the spine very lightly – make a smooth curve, pressing harder onto the paper only at intervals to create a flowing organic shape. Add some light tone to the lower leg to produce a sense of form.

Make several attempts at this drawing, pausing to critique what you have done before moving on. Working with a brush takes time to master; part of the challenge lies with the lack of tactile feedback from the paper.

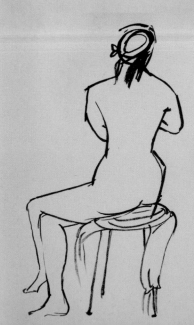

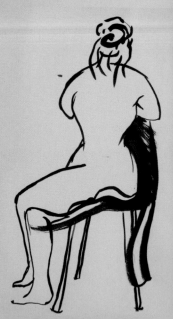

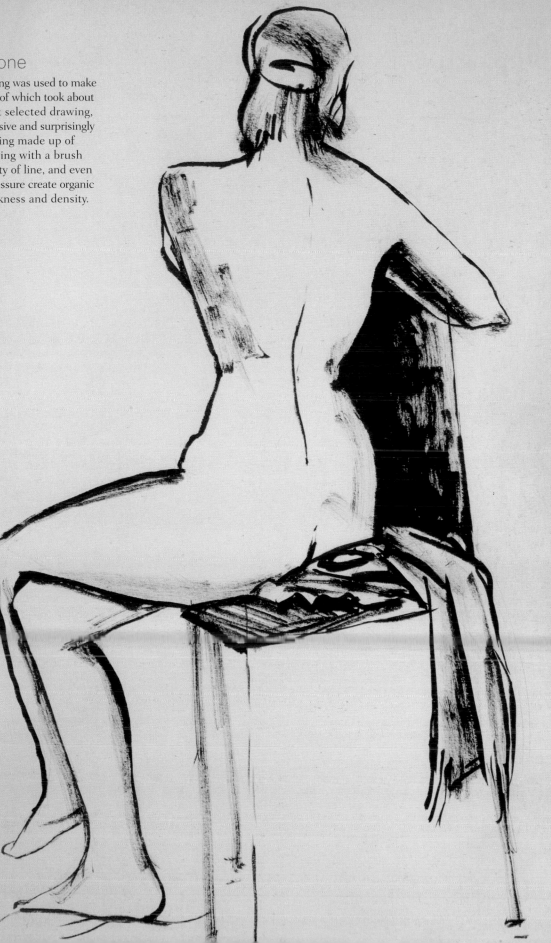

▶ Seven for one

Quick, gestural drawing was used to make seven drawings, each of which took about 10 minutes: the best selected drawing, shown right, is expressive and surprisingly accurate, despite being made up of very few lines. Drawing with a brush emphasizes the beauty of line, and even small variations in pressure create organic variations in its thickness and density.

8 Girl in a party dress

This playfully expressive study of a standing figure is more decorative than analytical because it employs colored pencil on a colored background, rather than stark black on white. The focus of the drawing is the surface of the boldly-patterned dress and the pose of the model: color is used nonrepresentationally to emphasize the subject. Colored pencil allows very fine, delicate work – a degree of precision in mark making that creates a drawing that could not have been achieved using heavier pastels.

EQUIPMENT
- Light blue-gray heavyweight watercolor paper
- Venetian red, white, rose pink, fuschia, evergreen, sap green, and hazel colored pencils
- Plastic eraser

TECHNIQUES
- Directional shading
- Foreshortening

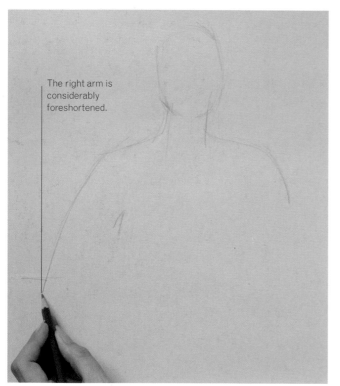

The right arm is considerably foreshortened.

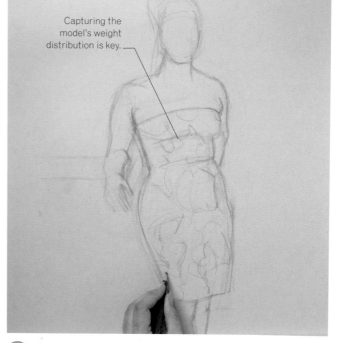

Capturing the model's weight distribution is key.

1 Pose the model to create a dynamic curve in the dress. Map out the outline of the body using the pale Venetian red pencil. Use the head as a basic unit of measurement, and ensure the body is in proportion (*see p. 22*). Trust your eyes in assessing the proportions of foreshortened limbs.

2 Determine the weight of the pose, which runs through the head to the back foot, and provides the central axis for the drawing. Continue sketching to establish the basic shape of the model: make multiple fine lines, keeping your marks free and loose, until you "find" the form.

BUILDING THE IMAGE

3 Loosely sketch the outlines of the pattern on the dress, and then begin putting down the base color with the white pencil. Color roughly at first, making marks on the diagonal to give the drawing energy.

4 Begin coloring the floral areas of the dress with the rose pink pencil, again working on the same cross angle to give the drawing consistency. Work quickly – the pose is a hard one for the model to sustain for long periods.

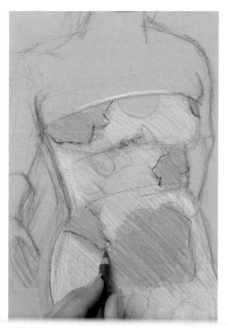

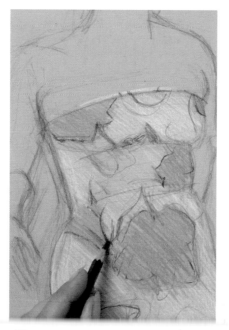

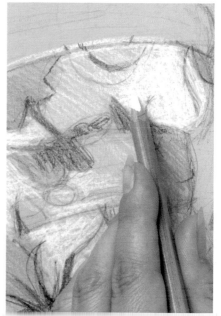

5 Outline the areas of rose pink color with the fuschia pencil: this addition of contrast helps to contain the floral areas and immediately lifts the drawing. Sharpen your pencils frequently to keep the lines crisp.

6 Add the details of the flower stems on the dress using the evergreen pencil. Reinforce the background white tone in the dress, making bolder directional marks with the white pencil.

7 Create areas of highlight using strokes of the white pencil at right angles to the previous white marks. Note how this produces a luminous sheen on the dress against the colored background.

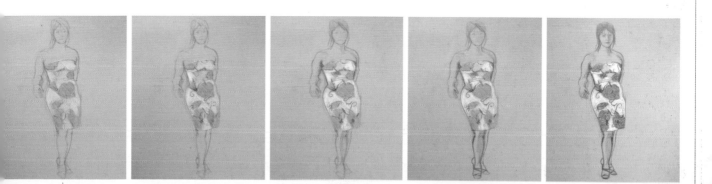

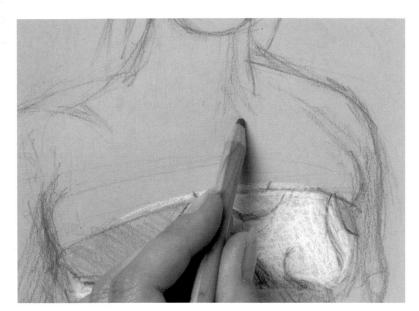

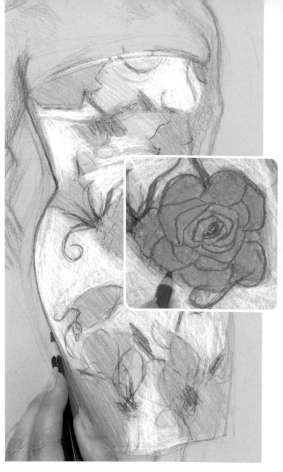

8 Introduce modeling to the skin with the sap green pencil (green and olive tones are present in skin); the blue of the paper carries the cooler skin tones. Work lightly – heavy tonal values in the skin will ruin the delicacy of the drawing and pull the eye away from the dress.

"Colored pencil is a highly controllable, precise, and forgiving medium."

9 Use the evergreen pencil to strengthen the line of the left side of the dress. This pulls that side of the body forward, emphasizing the twist in the model's pose. Draw the lines of the petals in the dress with the fuschia pencil.

10 Use the sap green pencil to add shadow and form to the calves. Soften the marks on the leg by rubbing them back gently with a plastic eraser.

11 Add detail to the feet and shoes with the Venetian red pencil; work a little more heavily in this area to ground the model.

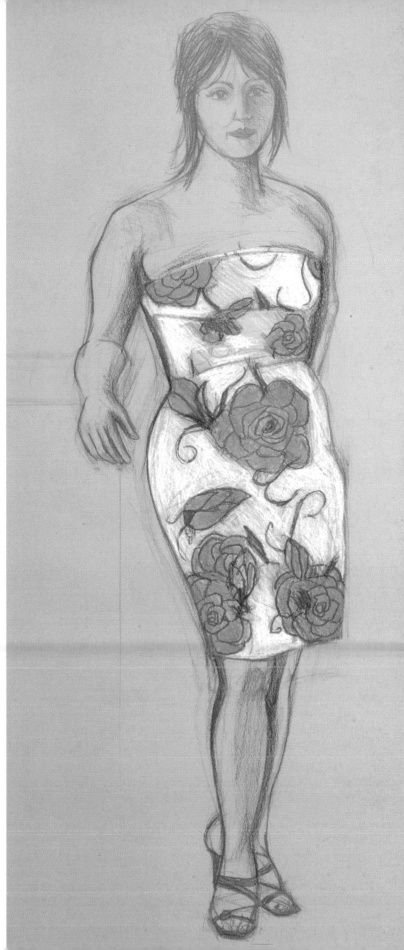

12 Draw the face and hair using the hazel pencil. Hold the pencil away from its tip; this allows the lines of the hair to become "kinked." The heavier weight of line in the hair balances the composition, allowing the face to remain lighter, more enigmatic.

MODEL BEHAVIOR

Always talk to your model to make sure she is comfortable, warm, and happy to hold a pose. Experienced life models will be able to suggest or modify poses that make for dynamic compositions. Look more at the model, with frequent glances, than at the paper – think of the process as tracing rather than analyzing the outline.

▶ Girl in a party dress

This is a personal, evocative study of the human form that implies familiarity with the subject – perhaps a friend or a partner. The informality of the approach is complemented by the deliberately relaxed pose and by the choice of colored pencil, which provides an intimate way of working – building up colors, forms, and tones stroke by stroke.

9 Self-portrait

The long tradition of self-portraiture among artists shows that the mirror gives us a very compelling viewpoint for a drawing. Part of the appeal of drawing yourself is practical – you always have a model available – but part lies in the challenge of marrying subjective and objective observation. Technically, you need to analyze what you see in the mirror and resolve it into line and tone, but emotionally, you are setting out to explore your self-image. Charcoal is an ideal medium for capturing the energy, personality, and rich detail of a self-portrait.

EQUIPMENT
- Honeycomb textured pastel paper in pale duck egg blue
- Willow charcoal stick
- Plastic eraser

TECHNIQUES
- Smudging and blending tone
- Erasing to create highlights

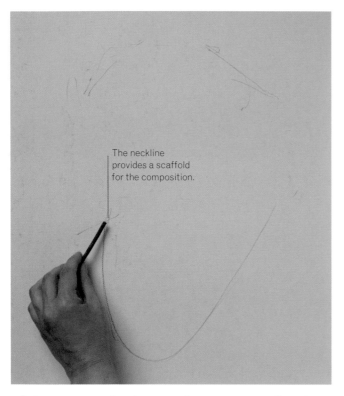

The neckline provides a scaffold for the composition.

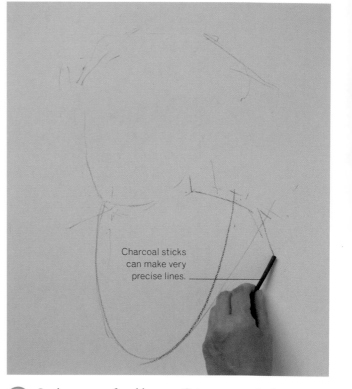

Charcoal sticks can make very precise lines.

1 Set up your easel and position the mirror – you will need to consider how to frame the portrait, how to crop your features, and whether you will be looking into the mirror or away. Begin by locating the extremities of the composition by marking out the top of the head and the neckline.

2 Settle on a comfortable pose. Orientate your body in a reproducible way – for example with one knee touching the side of the easel – to create reference points that help you return to your original position when you move. Continue mapping the outline of the head and shoulders.

BUILDING THE IMAGE

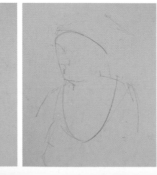
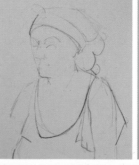
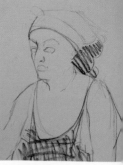

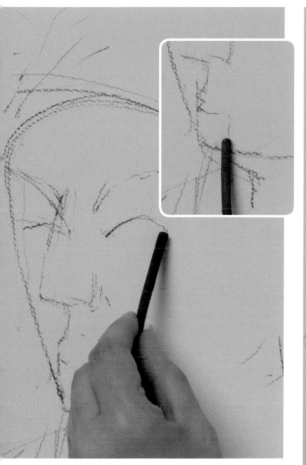

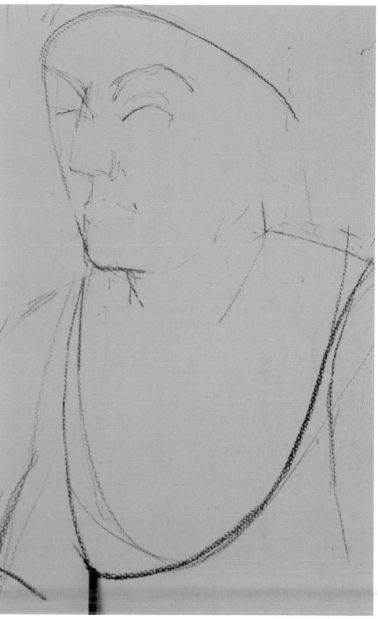

3 Assess the relationships between the features – the distances between the eyes, between the eye and the base of the nose, and the width of the nose. Make sure these dimensions are in proportion to one another; mark them in with light, erasable strokes of the charcoal.

WORKING SPACE

Large-scale self-portraits in charcoal require room to maneuver. Tape the paper to an easel to permit free movement of your arm; you can attach the mirror to the easel with a binder clip.

4 Continue establishing the positions of the features with respect to one another, and to the chin and crown of the head. Remember that the features take up a surprisingly small part of the head: the midpoint of the face, measured from chin to crown, is at the base of the eyes.

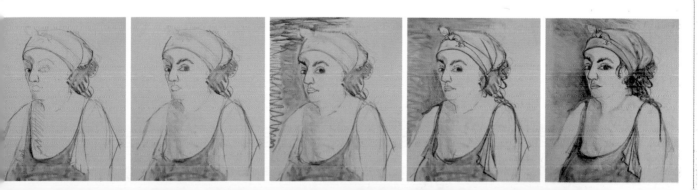

5 Make regular use of the eraser, reassessing and refining proportions as you go. The eraser is just as essential a tool as the charcoal; if you're not using it, you're not being sufficiently critical.

6 Examine your reflection; draw the face you see, not your mental image of that face. Identify the key characteristics – arched eyebrows and a strong nose – and ensure you render them faithfully, not as a caricature.

7 Add tone to the shirt, hair, and chest areas using quick, loose strokes of the charcoal. Blend these marks directionally with your fingertip to indicate the nap of the fabric and create a sense of solidity.

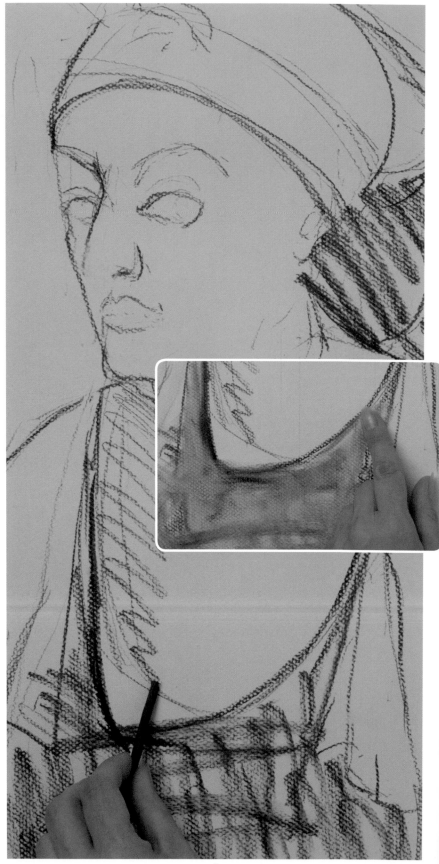

8 Refine the lines of the features using the fine tip of the charcoal stick. Establish the gaze of the eye – it is a key expression of personality. The gaze in a self-portrait will tend to be one of inquiry because you are inevitably analyzing the subject.

"Charcoal is fast, direct, and responsive, making it the least inhibiting of media."

9 Darken the eyes to bring expression into the face. Shade and blend the background to the left, bringing the head into relief; fade the tone gently to the right, leaving a blue "window" of untouched paper to the extreme right.

10 Use heavier line to accentuate telling aspects of your appearance – such as the folds and bow of the headscarf. Add character to the drawing by bringing these details into focus.

11 Build up heavier lines in the hair and fabric to inject dynamism into the work. Be brave – you sometimes need to disrupt the order you have created to reassamble more interesting forms.

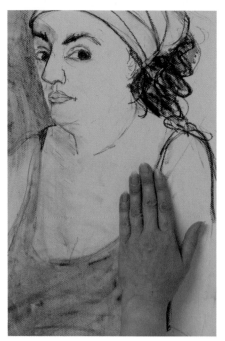

12 Rub back the bolder lines. Don't be afraid of leaving the footprints of your working, such as rubbings out and finger marks – they add an intriguing extra dimension to the drawing.

13 Use your finger selectively as a drawing tool to drag charcoal into forms. Draw the diffuse line of the bow in this way to lift it above the firmer lines of the hair that lies beneath.

14 Add final strengthening lines and more tone to the headscarf. Use the plastic eraser to take away tone from the shirt, leaving behind bright highlights. Erase the strong line to the left of the arm, the boundary of which is then held purely by the tone of the background.

15 Add further shading to the left of the head to pull its form forward. Rub back with a fingertip so that this tone has a lower value than the hair to the right; if the tones are even, the drawing will tend to flatten out. Note how the larger areas of tone pick up the honeycomb pattern of the paper, adding an extra textural element to the work.

► Self-portrait

Bold charcoal strokes and strong contrasts of light and dark are key to the impact of this work, capturing the visual drama of the face. The neckline and headscarf act as a frame within the frame of the drawing, pulling attention toward the face.

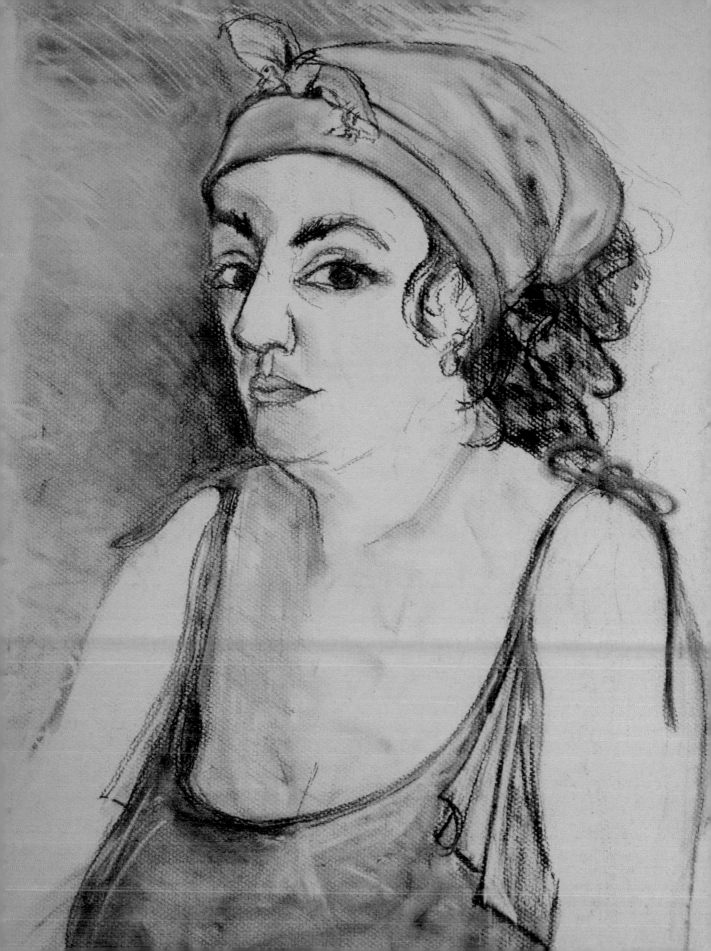

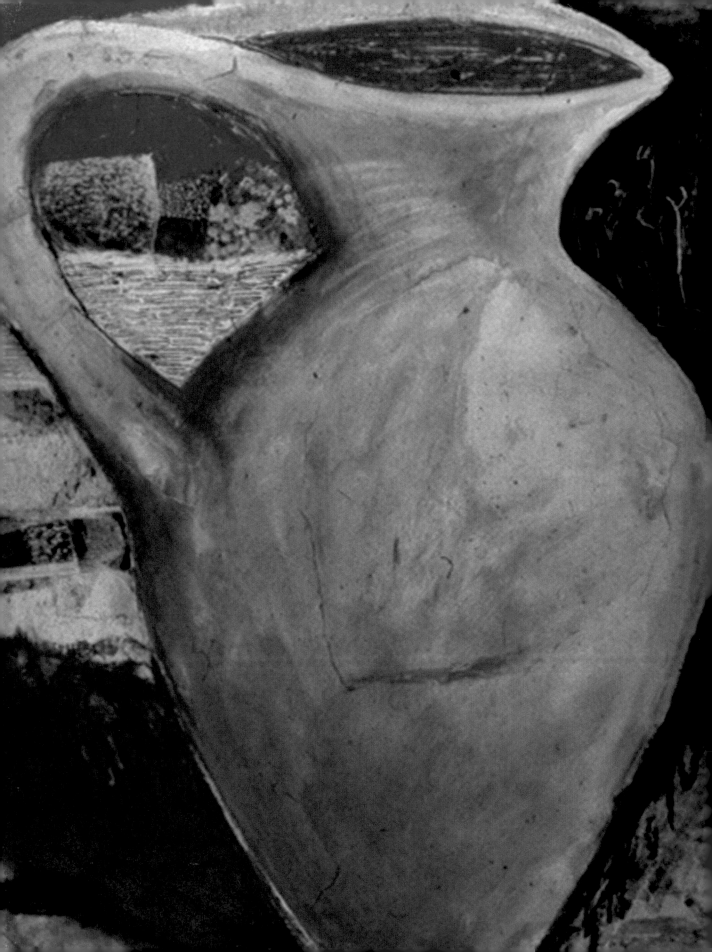

Concepts

"Drawing offers a huge
range of possibilities
for mirroring today's
preoccupations."

Process and ideas

Traditionally, drawing subjects were more or less restricted to the natural world, still life, and the human figure. This has changed; drawing today has few limits in terms of its subjects, materials, and techniques.

However, this unprecedented freedom can create its own tyranny. More than ever, it is essential to develop your own personal framework to work within and be clear about targeting your intentions and interests.

REINVENTING MEDIA AND SUBJECT

The range of drawing media is constantly expanding, and today, traditional techniques sit alongside new materials and digital processes, providing entirely new channels for expression.

New and mixed media allow revolutionary takes on old subjects, and are suited to more radical experimentation – exploring the nature of representation and of mind itself.

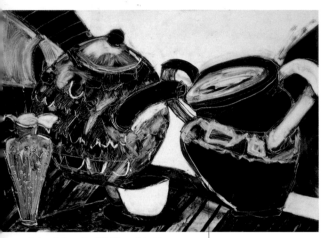

A traditional still-life subject is here tackled using mixed media – ink and pastel – drawn on a Plexiglas ground. With light seeping from behind, the chaotic drawing, with its distorted perspective, takes on a quirky cartoon-like quality.

Fisheye perspective

This representation of a figure eschews classical tradition in favor of emotional intensity. The closed pose, combined with dense, simplified areas of pattern and color, and lack of tone creates an iconic image of introspection.

Ink and gesso provide dense colors and solid whites.

A broad dark ink wash is the perfect base for the spirograph snowflake-like forms in white ink, which float on the surface of this mysterious and evocative drawing – is it landscape or abstract pattern?

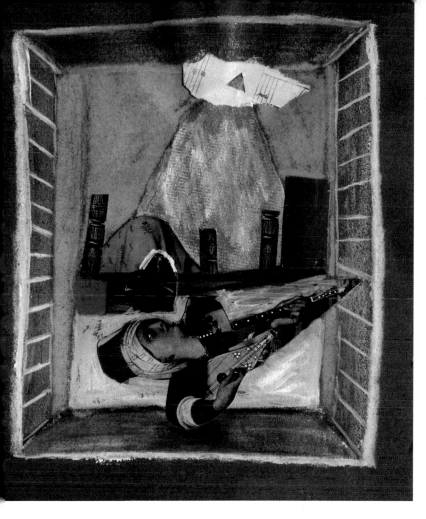

This drawing of a building, based on the conventions of architectural representation, is given a new edge by careful choice of media. The use of black and gold suggests power and gravitas, transforming the skeletal structure into a modernist temple.

A postcard of an old master painting is combined with other collage elements and placed in a surreal golden window that gives a view on to a stylized mountain. Formal perspective devices are used to create the illusion of an imaginary world.

TOWARD ANIMATION

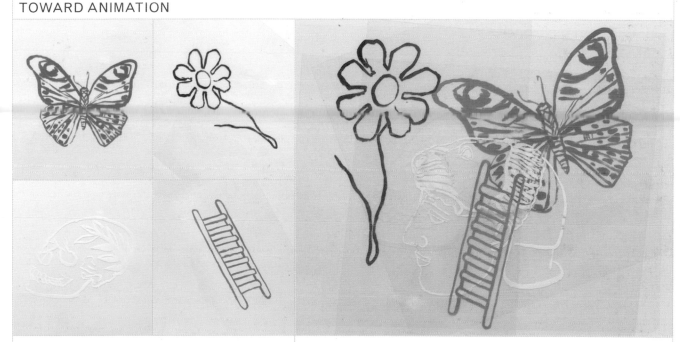

Experimenting with the ground of a drawing opens up new possibilities; inspired by traditional animation, these logo-like line images were drawn on to clear acetate.

Made separately, the drawings can be overlaid to form an entirely new graphic image. Moreover, this drawing has an existence in time – moving the elements relative to one another creates a new visual experience each time.

Drawing as a continuous process

Drawing practice is an ongoing process, and as with all creative acts, the more you do the better you will get. All your efforts – even those that seem unsuccessful – contribute to your development. If you do not achieve your desired results, the answer may not be to move on to new subject matter, but to try different approaches, media, and compositions. Repetition and formal exercises can also be useful in unlocking your creativity.

REWORKING THE PAST

Drawings are left unfinished or unresolved for a variety of reasons. A good learning exercise is to revisit old work with a fresh critical eye, appraise its strengths and weaknesses, and inject it with new life by adding collage elements, new colors, or textures. Drawings with a strong structural foundation and interesting composition make ideal subjects for reworking.

REVISITING A DRAWING

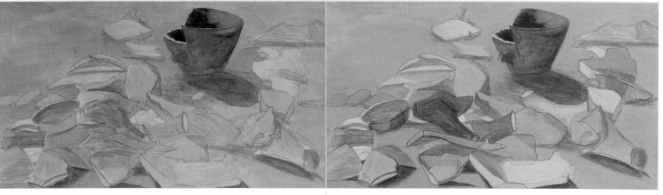

This pastel and ink drawing was mapped out but never completed; the colors are weak and do not enhance the composition.

Reinforcing the tonal areas and brightening the color with pastels and colored pencil completes the drawing.

CUTTING AND RECOMPOSING

Existing images can be combined and collaged to create interesting new visual descriptions that are far more than the sum of their parts. This approach works well with contrasting pairs of drawings; the opposition of lively and colorful, and static and linear, for example.

Two old drawings of very different styles – one abstract in energetic ink and shellac, and one figurative charcoal – are chosen to create the new work.

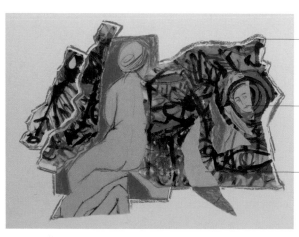

A new medium – pastel – is used to unite components.

Elements of other images can be added.

Torn edges of the paper set out new forms within the drawing.

The images are torn, cut, and juxtaposed to create a third dynamic, which was not present in either original.

DRAWING EXERCISES

Becoming technically adept at drawing gives you the ability to fulfil your creative intentions. Different people arrive at this point through different means; for some, it is illuminating to comprehend the pathways from brain to hand that underlie all creative mark-making. Exploring these connections through some simple exercises is interesting, although maybe a little unsettling.

Drawing with the "wrong" hand

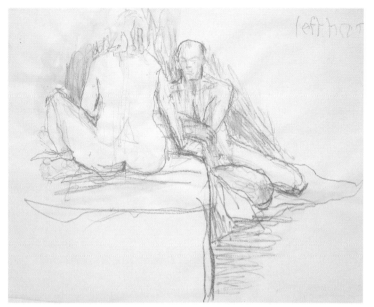

If you are right handed, draw with your left hand. You will concentrate much harder on the subject and become aware of your conscious intentions to move your hand.

Drawing by touch

Cover your subject – here coconuts – with a cloth and draw by touch rather than sight. This makes you access different sensory areas to find the information you need to make marks.

ONE SUBJECT, THREE APPROACHES

A Grecian vase drawn in a warm, advancing terracotta color displays its surface textures and almost falls foward, out of the drawing.

The same vase, drawn in stark white against black and the intense blue of the sea, possesses a far more dramatic quality.

A doorway and distinct horizon create depth in this version of the jug, which also plays with color theory.

Gallery

Inspiration for drawing in the modern era derives from a huge variety of sources and is shaped by a proliferation of new media.

▶ In the Car

This iconic image by Roy Lichtenstein draws its inspiration from comic-book culture. The artist would cut out and edit graphic images, using his selection as the basis for constructing larger works. Lichtenstein often used projected images to transpose pictures accurately on to working grounds.
Roy Lichtenstein

▼ Study for Crinoline

This drawing is part of a series of preparatory works for a sculpture. A few expressive lines in ink conjure up a sense of volume and texture in the dress, and contribute to a sense of fantasy.
Sophie Hammerton

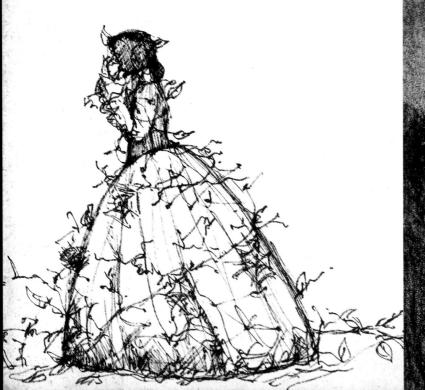

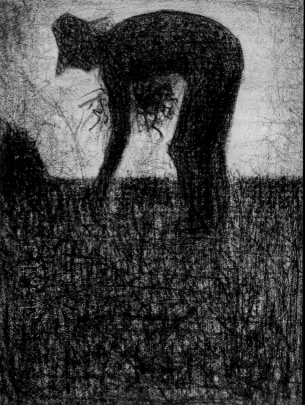

▼ Untitled Chalk on Paper

Repetition of fragile lines across a prepared surface creates rhythmic forms in this semi-abstract landscape, contained by a bolder horizon line. Suppressed color works in conjuction with the banding to evoke a childlike, rainbow-tinged view of the world. *Paul Klee*

▲ Quiet Move II

Uncommonly, a white line is used to define forms in this complex visual construction. Mixed media explore the explosive dynamics of sculptural form and the illusions of space and depth. *Roderick K. Newlands*

◄ The Gleaners

Compressed charcoal on a textured paper creates a busy surface in this simple drawing. The modular compositional and tonal contrast impart a dramatic edge to the actions of a field worker. *Georges Seurat*

► Mixed Media on Paper

Forms inspired by nature are caught up in a whirlwind; colored shapes ebb and flow across the prepared paper, drawing the eye repeatedly in a spiral on the pictorial plane. *Lorraine Cooke*

10 Archaeological finds

Drawing is illusion, and your choice of subject need not be constrained by what is really "out there." The subject of this drawing is a group of real terracotta objects – archaeological finds – combined with a photograph of a classical Greek scene. The two subjects are unified by harmonious composition and by the deliberate use of a restricted color palette. The warm brown and terracotta pastel pencils are sympathetic to both subjects, conjouring up both a sense of antiquity and earthy texture, and of the burnt Greek summer landscape.

EQUIPMENT
- Acid-free cream textured pastel paper
- Light burnt ocher, deep terracotta, sienna, and burnt umber chalk pastel pencils
- Ruler
- Dark terracotta, sienna, and ocher pastel sticks
- Plastic eraser

TECHNIQUES
- Blending pastels
- Combining sources

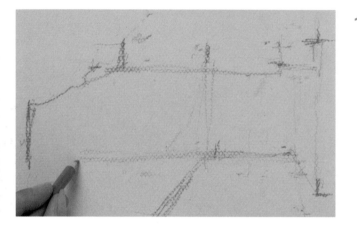

1 Carefully examine the photograph and begin mapping out the framework of the drawing's background using the light burnt ocher pastel pencil. Place the wall in the top center of the drawing – its position will determine the scale and composition of the foreground objects.

SURFACES

Pastel needs a surface with "tooth" for the pigment to stick. Rough textured or prepared papers are the best choice.

2 Continue establishing the background elements – work lightly so that you can erase your mistakes. Set out your pottery objects, illuminating them with a single spotlight to simulate the strongly directional quality of light on a Greek summer's afternoon, and begin drawing their outlines.

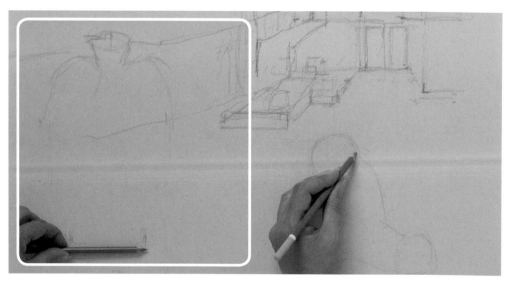

BUILDING THE IMAGE

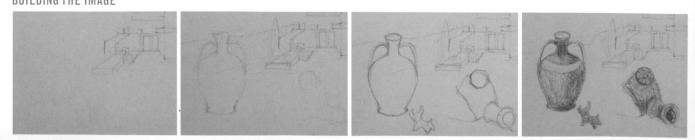

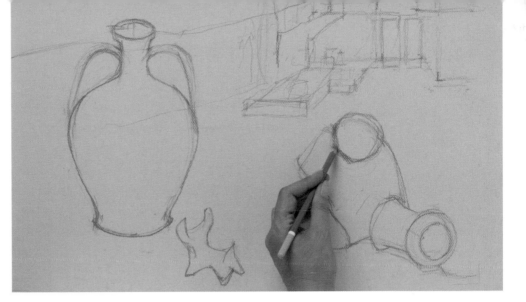

3 Sketch in the forms of the other pottery objects, measuring their size with your pencil if needed (*see p. 22*). Review the spaces between the elements, as well as their sizes and proportions, adjusting until you are happy with the composition.

"Objects come to life through their irregularities."

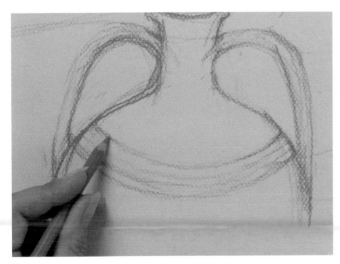

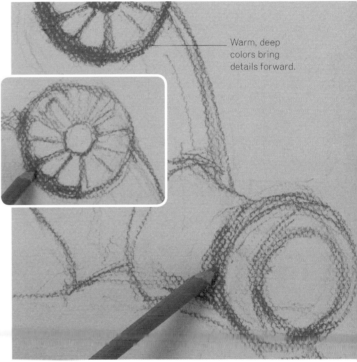

Warm, deep colors bring details forward.

4 Strengthen the lines of the pottery objects to set their positions. Rest your hand on a scrap sheet of paper to prevent smudging the marks below. Examine the asymmetries in the objects and make no assumptions about their shapes; draw what you see. Aim to identify and capture the objects' personalities.

5 Start adding detail to the broken pot using the deep terracotta pastel pencil to give depth to the floral relief. Analyze the forms and make sure you draw the floral relief you see rather than your idea of a flower. Establish the lip of the pot with the same pastel: note how the darker tone brings the front of the object forward in the drawing.

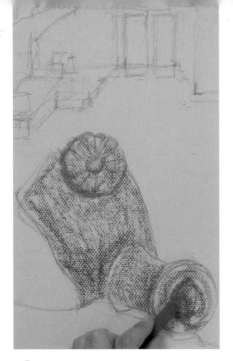

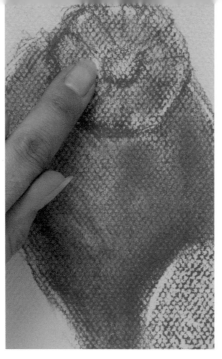

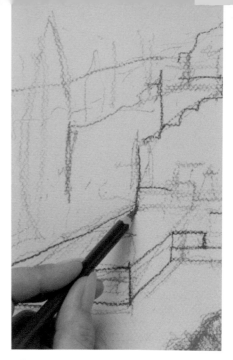

6 Begin shading the foreground objects to establish form and shadow; knock in the tone loosely with the dark terracotta pastel. Use the pastel selectively, with less tone in the highlight areas to emphasize the curved forms of the objects.

7 Smudge the surface with your fingertip to blend and refine the tone. Adjust the pressure as you smudge – more pressure in areas of heavier pastel coverage produces a darker tone with a more apparent solidity.

8 Return to the background and reinforce your faint initial lines with the sienna pastel pencil. Establish the framework of the buildings and the crumbling wall, adding the suggestion of individual bricks in selected areas.

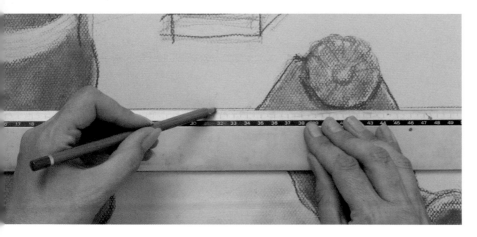

9 Draw a strong line with the ruler and the deep terracotta pastel pencil to indicate the edges of the table on which the objects rest. This provides a grounding for the still life. Ensure that the plane of the table matches the perspective of the background to unite the elements visually.

10 Reassess the shape of the objects as the drawing progresses: the beauty of chalk pastel is its ability to be repeatedly rubbed back and adjusted. Reinforce only the foreground lines you are happy with, using the sienna pencil, and blend away other lines using your fingertip.

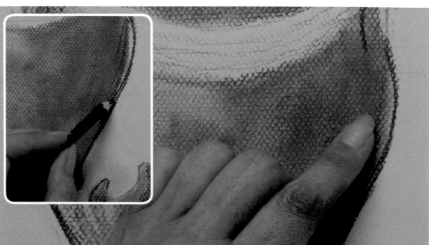

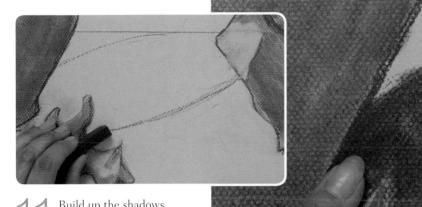

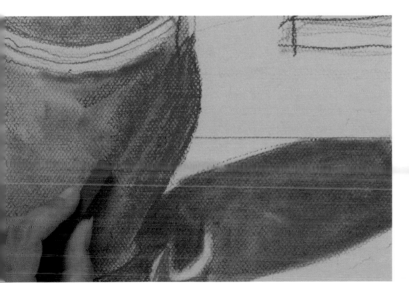

11 Build up the shadows using the sienna pastel stick; it is not a good idea to use gray and black for shadow areas when working in pastel because the results tend to appear muddy. Ensure that all extraneous lights are switched off when working on the shadows.

12 Build up the modeling on the shadowed side of the vase with the ocher pastel stick. Rub away at the applied pigment with the plastic eraser following the curved form of the pot; this creates interest as the pastel keys into the texture of the paper.

13 Add dense ocher to the side of the broken pot. Reassess the image, looking in particular at the negative spaces that are now emerging between the strong blocks of tone – these areas contribute to the integrity of the composition.

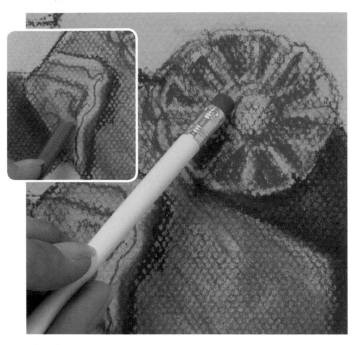

14 Build the edges of the objects with the deep terracotta pastel pencil; there's no need to work too finely, because the rawness of the drawing is part of its appeal. Create an edge to details by rubbing back the tone with a small eraser, rather than by introducing hard boundary lines.

15 Work heavily with the burnt umber pastel pencil, uniting the base of each object with the dense shadow that it casts. This serves to anchor the objects to the table surface and contributes to the three-dimensional illusion.

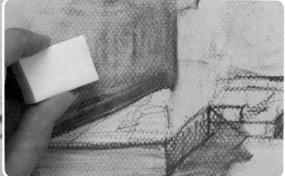

16 Add tone to the ruin in the background with the burnt umber pastel pencil. Hold the pencil loosely – the unsure line that results helps to make the background more recessive and reinforces a realistic sense of depth. Use the plastic eraser to smudge and soften the background tones – the focus of this drawing needs to remain firmly on the foreground objects.

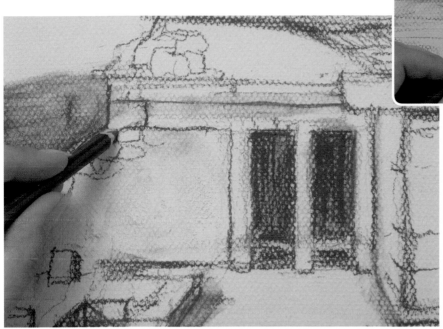

17 Add detail to the background and extend its tone to almost meet the still life objects; this helps to unite the elements in the drawing. Add burnt umber detail into the floral relief for a color link to the background.

▼ Archaeological finds

Subject, technique, and materials combine in this nonrepresentational drawing that summons up a sense of place and history. The earthy palette and textured paper contribute to this effect.

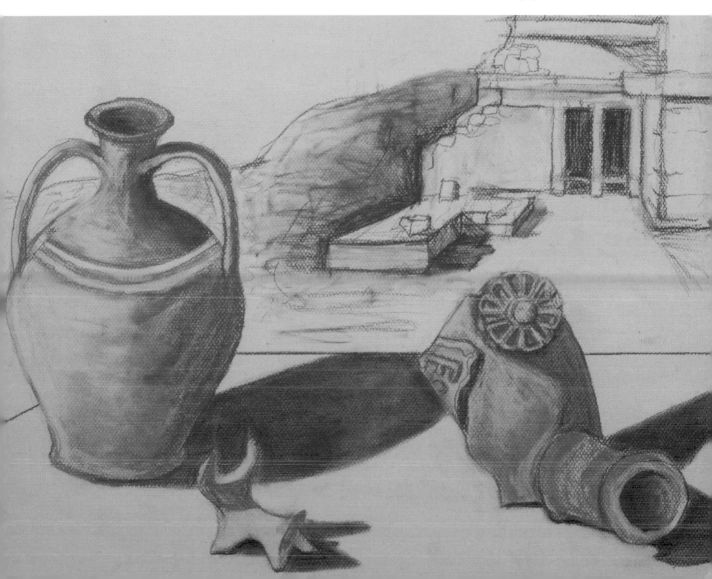

11 Projected image

Drawing over a projected image has a long tradition, stretching from the Renaissance to Andy Warhol – indeed, today's digital and slide projectors are derived from the camera obscura, the idea of which was first set out by Aristotle. Far from limiting your options, working over a projection opens up new opportunities – to work on a huge scale, to represent movement, or to explore cultural and personal icons. This drawing of geishas in a traditional Japanese setting uses bold pastel to capture a scene full of drama.

EQUIPMENT
- Heavyweight off-white drawing paper
- Projector
- B charcoal pencil
- Plastic eraser
- Light gray, dark purple, coral red, and burnt umber chalk pastel pencils
- Lemon yellow, soft orange, chrome green light, mid-gray, gray-green, ultramarine deep, ochre, deep yellow, orange, coral red, carmine pink, Mars violet, sky blue, and olive chalk pastel sticks

TECHNIQUES
- Tracing and developing a projected image
- Drawing on a large scale.

CHOOSING THE IMAGE

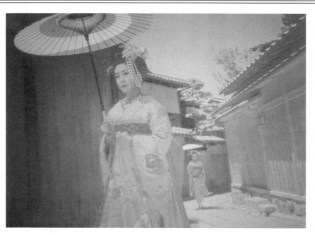

Selecting a suitable image for projection is key to success: choose a photo which contains formal elements that translate well into a drawing – perspective, a sense of place and atmosphere, and human narrative are all desirable.

> "Drawing is more than an academic exercise – it's about fulfilling your intentions."

Neutral gray line will not detract from the vibrant color of the drawing.

1 Position your projector on a vibration-free surface. Switch on the lamp and scale the enlargement to fit your paper. Lightly draw over the key outlines of the figures and the folds in the fabric using the light gray pastel pencil.

BUILDING THE IMAGE

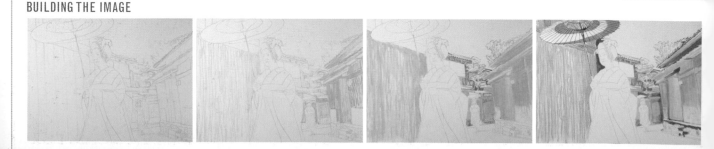

Loose marks indicate clusters of leaves.

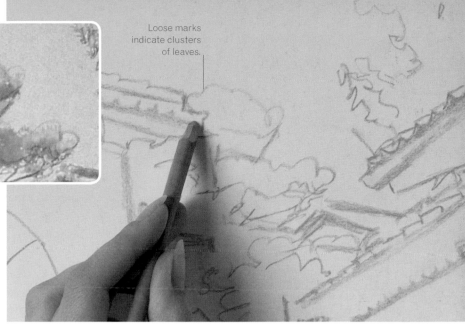

2 Establish the background, working with the light gray pastel pencil over the top of the projection. You can be far freer with your marks, and add more detail to the drawing than would be usual at this early stage because you can be confident that the proportions of the drawing are all correct.

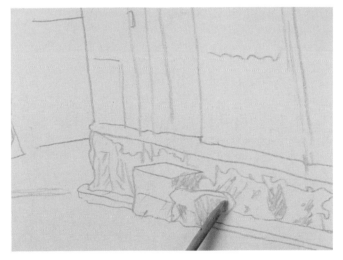

3 Bring hints of tone into densely shadowed areas of the drawing; the gray acts as an underlay for the colored pastel which will be added later.

SCALE DRAWINGS

Using a projector allows you to scale an image with exact precision. This is very useful if you have chosen to work on a large sheet of paper, or even a fresco, when establishing correct proportions can be difficult.

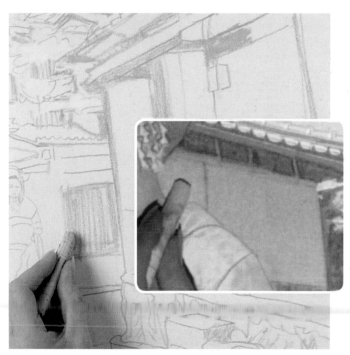

4 Examine the outlines with the projector switched off to ensure they are all complete. Switch the projector on again, and begin laying down the color and texture of the slatted wood and wall with the lemon yellow and soft orange pastel sticks to set up the solidity of the architectural elements.

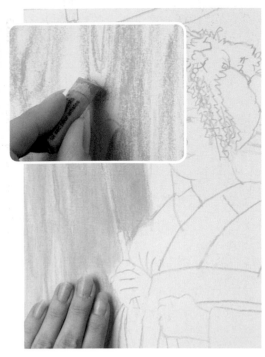

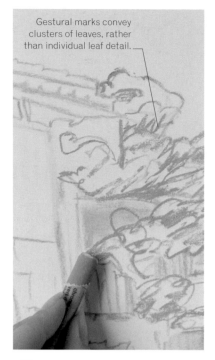

Gestural marks convey clusters of leaves, rather than individual leaf detail.

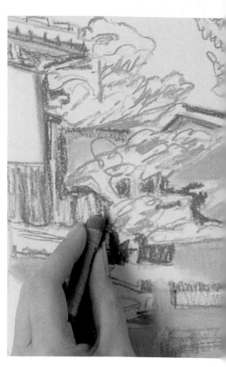

5 Smudge the soft orange of the walls to smooth out and prepare the surface, which will be later overdrawn with darker pastel tones. Smudge selectively, leaving some areas of the orange crayon raw and bold; this helps provide textural interest.

6 Use the chrome green light pastel stick to represent the trees in the background. Think of the color in the projection as a guide only – feel free to exaggerate for graphic effect.

7 Add density to the shadows behind the trees with the mid-gray and gray-green pastel crayons. Keep the tone rough – drawing too finely shifts emphasis away from the foreground figure.

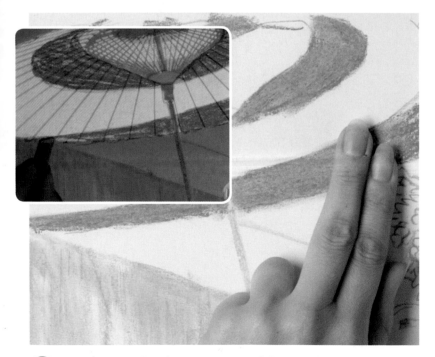

8 Add color to the broad concentric rings of the parasol using the ultramarine deep pastel. Smudge to create a uniform quality to these blue rings, which help to balance the warmer color range in the rest of the drawing.

9 Mark the spokes of the parasol using the dark purple pastel pencil. Keep the marks firm, precise, and regular to reflect the structure of the parasol.

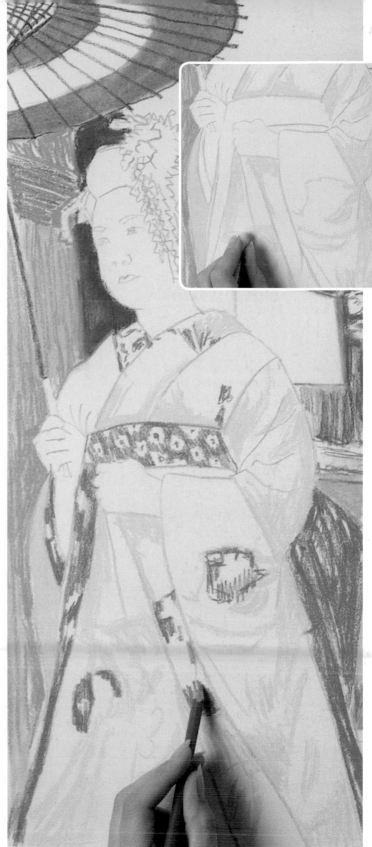

10 Color the hub of the parasol. Use coral red pastel pencil, which links with the red of the kimono and the lips of the geisha, and is the motif color for the drawing.

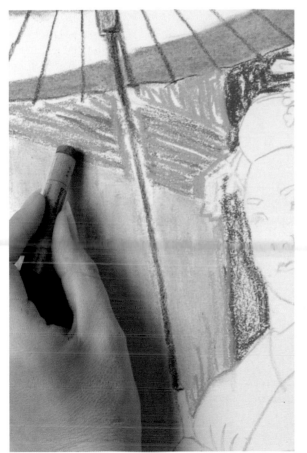

11 Use the mid-gray and ocher pastel sticks to add texture to the wooden sides of the building. Work over the soft orange undercoat, picking out patterns and knots within the wood.

12 Begin coloring the kimono of the lead geisha with a deep yellow pastel stick for the main areas and orange for the bustle; use the coral red for the pattern. These fiery colors contrast strongly with the muted background palette.

13 Draw the lips in coral red, and the face and hair in burnt umber pastel pencil, leaving a few highlights in the hair. The face is one of few white areas in the drawing, and so draws the eye.

14 Work on the rear geisha; use the carmine pink for her kimono and the deep yellow for the cummerbund. Draw the face and hair with the B charcoal pencil; work loosely so as not to pull attention from the leading figure.

15 Add tone to the path with the cool-colored Mars violet pastel stick. Leave this unblended to provide a rough contrast to the geisha. Reinforce the shadows cast by the figures and the building with the B charcoal pencil.

16 Color the sky with the sky blue pastel stick. Work the pigment with your fingertip to create an area of smooth, flat color that recedes into the background.

18 Lightly rub back the dark purple lines with a plastic eraser to make them less harsh. Add futher texture to the background using the olive pastel stick.

▼ Projected image

17 Add more deep yellow tone to the kimono, blending the tone with your finger. Outline the hands and margins of the robe with the dark purple pastel pencil – this contributes to the graphic character of the drawing.

Bold compositional elements and dramatic human forms give this scene a real sense of theater. With the projection removing the need to measure and examine the subject, the drawing becomes more concerned with the quality of mark making.

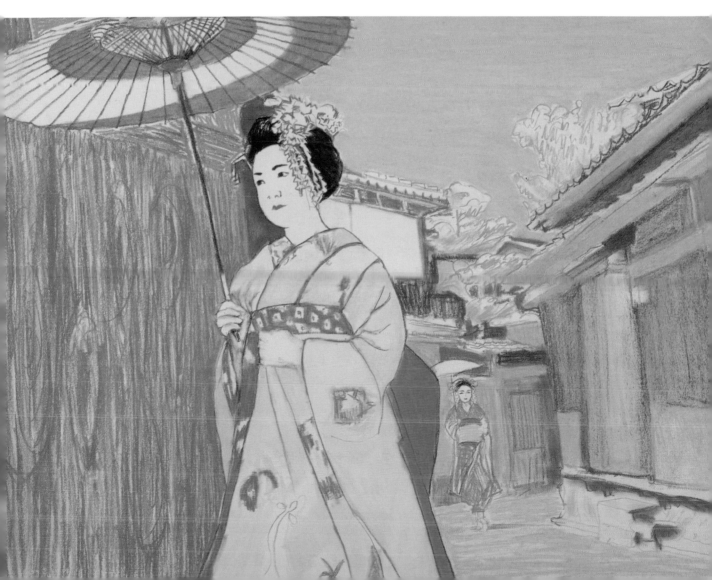

12 Geometric construction

Using geometric forms in drawing hints at a utopian vision – a world of order and regular beauty. Nature too displays mathematical geometry in its forms – albeit in a more complex manner – and the combination of pure geometry with abstract natural form makes an intriguing subject in this drawing. Executed in colored pencil in a sensitive palette, the drawing begins with the tracing of a floral motif onto isometric graph paper, used by architects and engineers, and then explores the interaction of abstracted forms and colors.

EQUIPMENT
- Wrapping paper
- Carbon paper
- Isometric graph paper
- Sticking tape
- Ballpoint pen
- Zinc yellow, light blue, water green, deep chrome, turquoise green, and soft plum colored pencils

TECHNIQUES
- Pattern tracing
- Shading to create relief

CHOOSING PATTERNS AND COLORS

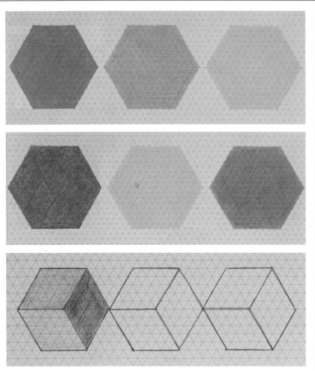

The subject of this drawing is repeated geometric form; spend some time experimenting with variants of pattern and color until you have achieved your desired effect.

Sheets taped together prevent movement.

1 Lay your chosen sheet of wrapping paper (or any other source of a natural pattern) over a sheet of carbon paper. Place these over a sheet of isometric graph paper and tape together. Trace the floral pattern with a ballpoint pen, which creates a strong but fine line.

BUILDING THE IMAGE

Carbon pigment remains loose and workable.

3 Decide on the size and shape of your underlying geometric form; the pattern is made up of repeated hexagons, measuring six triangles of the isometric graph paper on each side. Mark the skeletal positions of the hexagons using zinc yellow colored pencil.

2 Check your tracing early on to ensure that the carbon marks are sufficiently intense and that there is no movement in the paper. Keep the marks clear at this stage, though they will bleed later when color is applied.

"Repetition of a graphic motif has a curious romanticism of its own."

4 Choose a repeating pattern of color to fill the hexagons – diagonal rows with alternating light blue and water green; deep chrome and turquoise green; and zinc yellow and soft plum. Color the hexagons, rigidly following this pattern.

5 Guided by the isometric paper, vary the pressure and the direction of the shading to build up a faint cubic form within each hexagon. The resulting cubic patten has strong dimensional qualities that throw the overlying floral pattern forward, as if on another plane.

6 Work around the outlines of the flowers, but don't be too concerned if you cross the edges; the overlying colors of the flowers will create a glow around the boundary lines.

7 Bring out the cubic forms that you have already established within the hexagons. Add denser shading to the left-hand faces of the cubes, while keeping their tops and right-hand faces lighter to give the impression of directional lighting; avoid making the edges of the cubes too strong, otherwise the lines could conflict with the floral pattern.

8 Color the foreground flowers and stems working from the top of the drawing down. Use the same colors as those in the background, but for each foreground flower use the color of the background hexagon immediately to its left. Following this preset system, a clear pattern of color emerges.

▶ Geometric construction

A limited palette of cool candy colors gives this drawing a contemporary pitch and demonstrates the possibilities of working from second- or third-hand representations of nature.

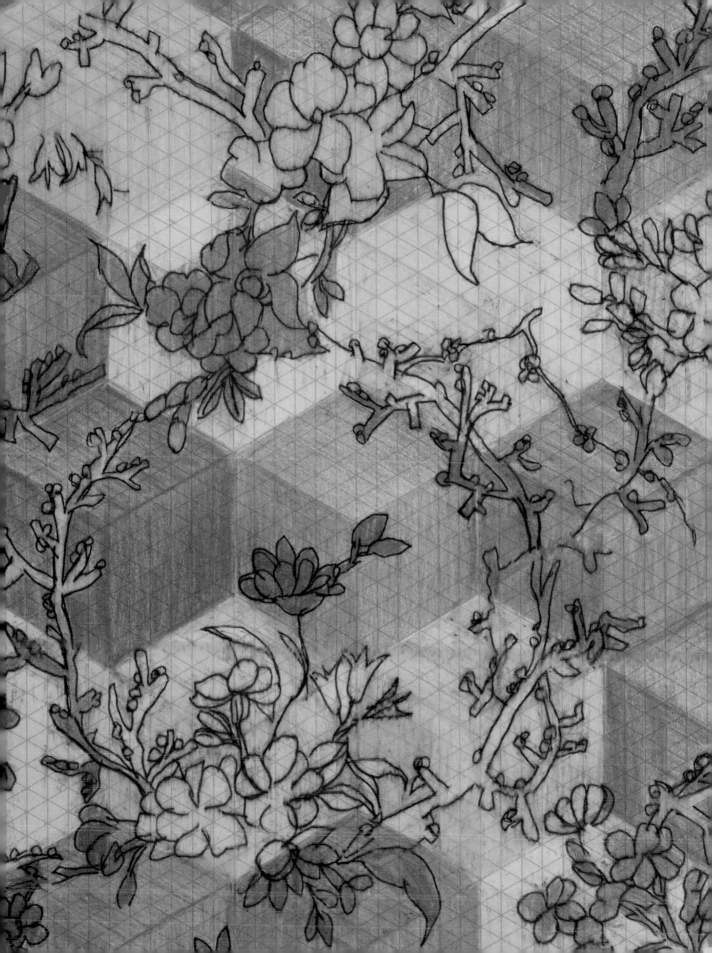

Glossary

Abstract
A drawing or other work of art that is intentionally non-representational.

Acetate
A transparent or translucent plastic, available in various colors, that can be used as a basis for drawings and overlays.

Advancing color
A warm color, such as yellow, red, or orange, that appears to bring a drawn surface toward the viewer's eye.

Allusive
A type of image that makes indirect references to other objects or circumstances, inviting and challenging the viewer to explore the connections between the two.

Art paper
Drawing paper made from cotton pulp, rather than wood pulp, for better surface textures and enhanced archival qualities. It is usually thicker than office or sketching paper to prevent buckling when wet, and may be coated with a fine clay compound that creates a smooth surface on one or both sides.

Axonometric
A method of drawing a plan view, especially of a building, where all the lengths are drawn in exact proportion to their true dimensions, and circular forms are drawn as circles rather than ellipses. It is used in technical drawings by designers, engineers, and architects.

Blending
Mixing colors or tones on the paper surface so that they blur from one to another. The blending tool can be a finger, a shaper, a tissue, or a rag. Charcoal and pastel are good media for blending.

Calligraphy
The art of decorative writing, but also used to describe a form of fluid drawing, usually with ink and brush.

Collage
The art of creating a visual assemblage of different forms to make a new whole.

Conté crayon
A drawing medium made of compressed pigment – usually an earth tone – mixed with a wax or clay base. Square in cross-section and relatively hard, it allows for more precise marks than softer pastels.

Contrast
The degree of tonal separation or gradation in a drawing.

Crosshatching
Crisscrossing parallel lines to create tone. The closer the lines, the denser the tone. A good technique in linear media, such as pencil and pen.

Dip pen
An ink pen composed of a metal nib with capillary channels, mounted on a handle or holder, often made of wood. In contrast to a fountain pen, the dip pen has no internal ink reservoir.

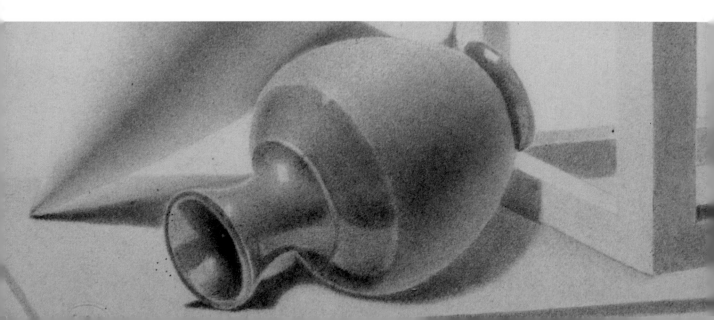

Dry painting
A term sometimes used to describe drawing with pastels.

Expressionism
Art characterized by its focus on subjective feelings, and its use of symbolic colors and exaggerated imagery.

Fixative
Liquid resin spray or atomizer used to glue and consolidate the loose surface produced when working with media such as pastel or charcoal.

Foreshortening
The effect of perspective that makes forms appear to get smaller with distance, particularly noticeable in figure drawing, when it distorts the proportions of the body.

Framing
The act of applying a physical frame to a drawing to protect and enhance its presentation. Also, the introduction of elements into a drawing that set out areas of space within the composition.

Futurism
An artistic movement of the early 20th century. Futurism glorified the technological progress, energy, and violence of modern society. Typical of the movement were dynamic compositions of superimposed and interlocking forms.

Gaze
The depiction of the eyes of a subject, not just as pure form, but as an expression of the personality and mood.

Gesso
A mixture of calcium carbonate, pigment, and an animal-derived glue – or now more commonly acrylic polymer medium – used to prime a drawing surface. Gesso produces a finely textured ground.

Gestural drawing
A style of drawing that explores the form and movement of an object in space. It may look realistic, but more often gestural drawings convey just a sense of overall form.

Graphite
The carbon–clay mix used in pencils. Graphite sticks are pure graphite without the wooden casing.

Ground
The drawing surface, most often paper.

Haystacking
Repeated layered cross-hatching at various angles, used to build up dense shadow areas in a drawing.

Highlight
The brightest area of illumination on a form, which appears on that part of the surface most perpendicular to the light source.

Impressionism
A 19th-century art movement with works characterized by a focus on light and space, and the use of unmixed primary colors and small strokes to simulate actual reflected light.

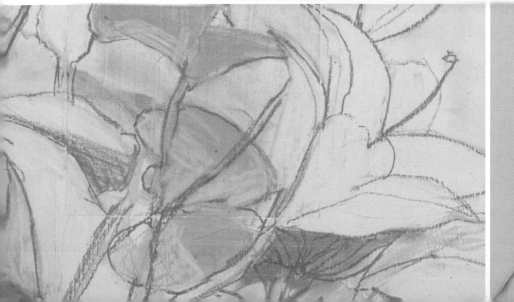

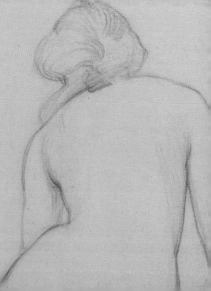

Incident light
The light falling upon an object, rather than that reflected from its surface.

India ink
Used for both writing and drawing, a type of ink that usually includes pigment mixed with a solvent and binder (traditionally shellac), which dries to a water-resistant permanent line.

Life drawing
Drawing a human figure from observations of a live model.

Line
The fundamental element of a drawing: a line has length, width, tone, and texture. It may divide space, define a form or contour, or suggest a direction of motion.

Linear perspective
A method of portraying three dimensions on a flat surface by showing how parallel lines, for example of a road, appear to converge in the distance.

Medium
The drawing material, such as charcoal, pen, pencil, or pastel (media in the plural).

Mixed media
The use of more than one medium to create a drawing, for example, the combination of graphite and pastel.

Negative space
The gaps between objects, and between objects and the frame of the drawing. Negative space is as important as positive form in creating a harmonious composition.

One-point perpective
In linear perspective, parallel lines are at right angles to the picture plane and meet at a vanishing point on the horizon.

Pastel
A color drawing medium in which powdered pigments are bound with gum or another binding agent into sticks. Soft pastels, also called chalk pastels, are powdery. Conté crayons are harder. Both come in pencil form. Oil pastels are sticky, and closer to painting media. A drawing made with pastels is called a pastel.

Perspective
A drawing made in perspective looks like a vision of the real three-dimensional world through the use of modeling, linear perspective, and color.

Positive shape
The outline created by an object in a drawing.

Prepared paper
A sheet of paper that has been prepared by coating with gesso, another pigment, or a textured ground.

Projection
The use of a projector, which may be a slide, overhead, or digital projector, to enlarge an image on to a wall or easel. The projected image is then used as the basis for the drawing, providing tonal, color, and perspectival guidelines.

Proportion
The accurate relationship of part to part in a realistic drawing. Also relates to a sense of balance.

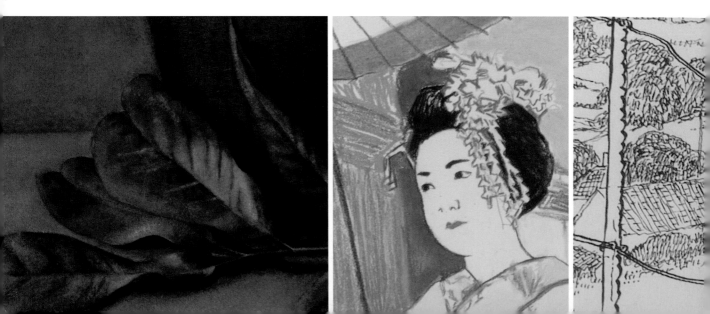

Recessive color
A cool color, such as blue or green, that appears to pull a drawn surface away from the viewer's eye.

Release
The use of a solvent, often but not always water, to free pigment from drawn marks. Release of the pigment creates the effect of a wash around the harder drawn lines.

Representational
A drawing that sets out to achieve a near-likeness of the objects being drawn. Drawings that strive to achieve the qualities of realism.

Shadow
The darkness cast when light is obscured, either on an object, or by it.

Silhouette
A drawing made up of an outline of an object or figure, especially the human profile, filled in with solid color.

Stencil
A template made by cutting out a design from stiff cardboard. Pigment is applied through or around the cut areas of a template so that the pattern will be reproduced on the ground below.

Still life
A representation of inanimate objects, whether natural or synthetic.

Texture
The actual or suggested surface quality of a drawing. Texture can be created by using skillful drawing techniques, erasing, rubbing, or employing specific materials.

Tone
From white to black, how light or dark something is, regardless of its color. Some colors are inherently light or dark in tone: yellow, for example, is always light.

Tooth
The raised grain of textured paper, which bites into the medium applied to it. Powdery media, such as charcoal or soft pastel, need paper with a tooth to stick to the surface.

Two-point perspective
In linear perspective, an object such as a building has vertical edges parallel to the picture plane, but its sides are seen as angles. The horizontal lines of the sides appear to converge at two separate vanishing points on the horizon.

Underdrawing
A preliminary drawing, often in faint charcoal or pencil, in which the outlines of the composition are sketched in preparation for detailed work over the top. This work may be carried out using different media.

Vanishing point
In linear perspective, the point where receding parallel lines appear to converge.

Vignette
A drawing in which the tones fade gradually away until they blend with the surface. Also used to describe a small decorative drawing.

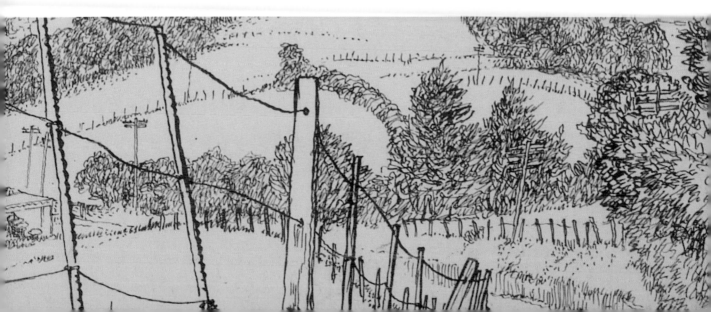

Index

Acknowledgements

AUTHOR'S ACKNOWLEDGEMENTS

Thanks to the Norwich School of Art and Design for supporting this book in a variety of ways, especially through the generous use of studio space and access to the School's drawing collection. Thanks also to Kurt and Rodney for their very practical support during the photo sessions at the School. Finally I would like to acknowledge the support of Chris and Louie for their patience and help during the making of this book.

PRODUCER'S ACKNOWLEDGEMENTS

Many thanks to Maddy King and Kati Dye at cobalt id for editorial assistance, and Dorothy Frame for indexing.

PICTURE CREDITS

Key: t=top, b=bottom, l=left, r=right, c=center, NSAD = Norwich School of Art and Design Drawing Archive

p.2: Diana Lamb; pp.6–7: C. Cobbett, NSAD; p.8 Nigel Potter (tr); p.9: Andrew Gibbs (tl); Sophie Hammerton (tcl); H.L.Wilson, NSAD (tcr); p.10–11: J. R. Barnett, NSAD; p.13: Unknown, NSAD (tl); p.15: Denton Burgess, NSAD (br); p.19: Andrew Gibbs (t); p.20: Unknown, NSAD (b); p.21: Josephine Brett (b); p.23: Sophie Hammerton (bl); pp.24–25: Unknown, NSAD; p.26: Unknown, NSAD (br): p.27: Galleria Nazionale delle Marche, Urbino, Italy, Alinari / The Bridgeman Art Library (t); Mathew Ramsell & Andrew Gibbs (c); Mathew Ramsell (b); p.29: The Art Archive / Fine Art Museum Bilbao / Dagli Orti (b); p.30: Digital Archive Japan / Alamy (r); p.32: National Gallery of Scotland, Edinburgh, Scotland / The Bridgeman Art Library (t); Unknown, NSAD (bl); Andrew Gibbs (br); p33: Haags Gemeentemuseum / The Bridgeman Art Library (t); Emily Cole (b); pp.50–51: H. L. Wilson, NSAD; p.52: Unknown, NSAD (br); p.54: Diana Lamb (bl); p.56: Andrew Gibbs (tl); JR Barnett, NSAD (tr); p.57: C Cobbett, NSAD (t); Museo d'Arte Moderna di Ca' Pesaro, Venice, Italy, © Succession H. Matisse / DACS / The Bridgeman Art Library (c); H. L. Wilson (b); pp.74–75: HL Wilson; p.76: CW Hobbins (tl, tlc); CE Wright (bl, cr, r); p.77: WH Freeman, (l&r); p.78: Derick Greaves (cr); Nigel Potter (bl); Sophie Hammerton (c); C.Cobbett, NSAD (br); p.79: C. W. Hobbins, NSAD (l, br); C. Cobbett (tr): p.80: Private Collection / The Bridgeman Art Library; p.81: © Estorick Collection, London, UK, / The Bridgeman Art Library; Emily Cole (b); p.82: AJ Munnings, NSAD (t); Unknown, NSAD (bl); Sophie Hammerton (br); p.83: British Museum, London, UK / The Bridgeman Art Library (tl); Musée Toulouse-Lautrec, Albi, France, Giraudon / The Bridgeman Art Library (bl); HL Wilson, NSAD (r); p.100: Sarah Horton (r); p.101 Andrew Gibbs (tr); p.103: Diana Lamb (tl); p.104: Scottish National Gallery of Modern Art, Edinburgh, UK / The Bridgeman Art Library (t); Sophie Hammerton (bl); British Museum / The Bridgeman Art Library (br); p.105: Roderick K. Newlands (tl); Private Collection / The Bridgeman Art Library (tr); Lorraine Cooke (b)

All jacket images © Dorling Kindersley.